IMAGES
of America

PORTAGE PARK

To Elaine, another
Portage Park Native,
enjoy!

9-20-08

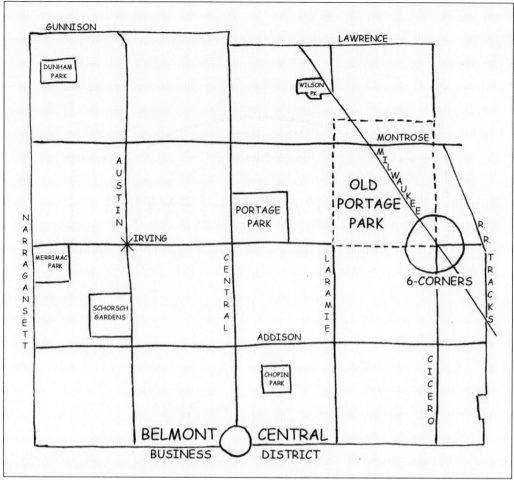

Portage Park stretches from the railroad tracks just east of Cicero Avenue to Narragansett Avenue on the west between Belmont and Lawrence Avenues extending farther north to Gunnison Street west of Central Avenue. Portage Park's exact boundaries have been variously presented over time, with press from the *Chicago Daily News* maintaining that the neighborhood went all the way west to Harlem Avenue in 1922. The borders of Portage Park presented in this book follow the basic outline set out by the Chicago community area map, with a slight modification in the neighborhood's southwest corner to simplify its boundaries.

On the cover: Portage Park the park has been the backyard for Chicago's northwest side for almost a century now. It gave both the area and its new residents a sense of identity, a place where the neighborhood could escape from the grips of city life to relax in the background of this green oasis. This flagstone pond so typical of the park's decor is no longer there today. (Courtesy of the Chicago Park District.)

IMAGES
of America

PORTAGE PARK

Daniel Pogorzelski and John Maloof

ARCADIA
PUBLISHING

Published by Arcadia Publishing
Charleston SC, Chicago IL, Portsmouth NH, San Francisco CA

Printed in the United States of America

Library of Congress Catalog Card Number: 2008920512

For all general information contact Arcadia Publishing at:
Telephone 843-853-2070
Fax 843-853-0044
E-mail sales@arcadiapublishing.com
For customer service and orders:
Toll-Free 1-888-313-2665

Visit us on the Internet at www.arcadiapublishing.com

This book is dedicated to local legend Ralph Frese and his wife, Rita.

CONTENTS

ACKNOWLEDGMENTS

Firstly, we would like to thank our families and friends for the support they gave us during the long process of researching and writing this book. The help of our loved ones was the glue that held us together through this daunting task.

We extend our gratitude to the following people and organizations for their help in our quest for pictures of this community scrapbook we have assembled for Portage Park. In giving us access to their photograph collections, they have rendered a great service to the community, even if we were unable to use their pictures. First and foremost, we thank the lovely Jennifer La Civita Kimbrough and Dave Panico with the Portage Park Center for the Arts, without which this book would have not been possible. We thank Frank Suerth and the board members of the Jefferson Park Historical Society; Rich Lang of the Irving Park Historical Society; Elaine Coorens, the author of the Wicker Park book, as well as Julia Bachrach and Sherida Hudak of the Chicago Park District; the staff at the archives of the Evangelical Lutheran Church in America; Doug Markworth at St. John's; Sister Michaelina from St. Ladislaus; Rose at Our Lady of Victory; Fr. Jason Malave from St. Bartholomew; Pat Fergus at St. Robert Bellarmine; Marge Scholze and Midwest Bible Church; Allan Firak from Montrose Baptist Church; Fr. Dimov Bojidar from St. John of Rila the Wonderworker Bulgarian Orthodox Church; the Polish Museum of America; Royna Johnson; Phil and Ken Little; Rudy Kubica; Mario Novelli; Mary Clemente; Jane Ohlin; Reszke and Jaeger Funeral Homes; Community Savings Bank; Augustino and Catherine Napoli; the Andolino family; Jennifer Rzadski and Jim Sullivan from Portage Park Elementary School; Charles Guengerich, president of Wilbur Wright College; principals Jerry Travlos at Smyser Elementary School and Lloyd Ehrenberg at Ernst Prussing Elementary School; Julie Lynch at Sulzer Regional Library; and the staff at the Austin-Irving and Portage-Cragin branches of the Chicago Public Library.

We would like to thank the following people for their advice and assistance: Joe Videckas, Al Opitz, George Borovik, Victoria Granacki, Joe Angelastri of City News, the Polish American Association, Greg Borzo, and Majed Abdelal for his computer wizardry. Thanks to John Pearson and Melissa Basilone for all their editorial guidance.

Daniel would like to extend a special thanks to Kim Tazbazian for all her goodness and flexible scheduling as well as the rest of the delicatessen crew at Dominick's Finer Foods with a special tip of the hat to Mark Scala.

INTRODUCTION

First came the Native Americans, then the explorers, the fur-trappers, and the frontiersmen. The receding waters of glacial Lake Chicago, the predecessor of today's Lake Michigan, had left the soils of today's Portage Park marshy and damp in its wake. While this wet soil would prove to be a serious problem for the farmers who would later settle here, this was a great boon for those traveling through the area. Water is one of the oldest ways to travel over long distances, and most ancient settlements were built near it, among other reasons, to facilitate communication with the outside world, a notion that even the Romans kept in mind as they assembled their vast empire. This water gave life to Chicago, sandwiched between the Great Lakes and the reach of rivers bound for the Mississippi River and the warm shores of the Gulf of Mexico. Only its strategic value could overcome the inhospitable nature of this terrain, which was after all the last part of Illinois to be settled, and the revolutionary canal that Louis Jolliet and Fr. Jacques Marquette imagined in their 17th-century travels would still take more than 100 years to materialize.

However long it took and however painful, the canal was finally built and the city born. Chicago burst forth with a bang, and people of all walks of life and every corner of the world came here to try to strike it rich, as they still do. Industry boomed and herds of people would follow the herds of cattle bound for the stockyards. The city's population was already 110,000 on the eve of the Civil War, a far cry from the 4,000 when it was first chartered in 1837, and in the span of just 10 years between 1880 and 1890, the population doubled from 500,000 to over a million citizens. Expansion became inevitable, and Jefferson Township, a quiet setting for so-called truck farmers was one of the many areas that Chicago annexed in 1889. This township was a wide expanse, spanning the area between what is today North and Western Avenues as well as Harlem and Devon Avenues, consisting mostly of open prairies. Once again opportunity brought forth those seeing their chance to capitalize on the possibility of striking it rich. Developers like Edmund Szajkowski, Albert J. Schorsch, and firms such as Koester and Zander transformed the prairie into part of the residential fabric of the metropolis.

Portage Park was one of these neighborhoods carved out of the plains. Its development was in many ways atypical of other communities on Chicago's northwest side, taking shape around the fringes of older suburbs that had formed along the city's periphery or, as some old-timers in the neighborhood say, "like a pretzel." The island of farms quickly vanished as brick bungalows and "two-flats" popped up seemingly overnight with whole neighborhoods appearing out of the prairie. Organizations and institutions followed the exodus of people into Portage Park, bringing St. Patrick's High School from the Near West Side and the Polish Welfare Association from Polonia Triangle. Often the catalyst would be the building of a church, frequently centered

around ethnicity, a fact not lost on developers eager to sell lots. The result would be that people would lure in friends and family from the old neighborhood to settle near them, leading to the mini ethnic enclaves that once dotted Portage Park.

Yet it was the park itself in Portage Park that really brought the community together, both figuratively and literally serving as its heart. Prominently located at its center, it united the different neighborhoods that began as extensions of the older surrounding areas of Jefferson Park, Belmont-Cragin, Mayfair, Irving Park, and Dunning. This attachment to the park itself was not the fruit of the wishful idealism of the Progressive movement but the fulfilling of a basic human need that had long gone unmet. To immigrants and their children who chose to make this area home, the greenery of Portage Park could not be overstated. As Ellen Skerrett notes in her essay on Portage Park in *The Chicago Bungalow*, people growing up in the congested industrial areas along the Chicago River such as Polish Downtown or Goose Island felt lucky if they saw trees, much less parks in the neighborhoods they lived in. The value that these residents had for Portage Park was most visibly seen in the sizably higher home prices people were willing to pay to live alongside the park itself.

Portage Park, like the rest of Chicago's northwest side, is often overlooked because of its blue-collar stigma. Yet the neighborhood possesses some truly impressive attributes and exciting history. There are the movie palaces such as the Patio, the Portage, and the former Belpark Theaters, in addition to the area's grand temples and once opulent hotels. The area is rich in history with two sites on the National Register of Historic Places, as well as the spot of an old inn where both Abraham Lincoln and his rival Stephen Douglas reputedly stayed. During Prohibition, the Irving Hotel served as an informal emergency room for wounded gangsters coming to get stitched up, with John Dillinger himself making visits. It was in Portage Park that the Polk brothers opened their first store, Central Appliance and Furniture, in 1935 in the Belmont-Central Business District. The Smashing Pumpkins played their first show in the now closed Chicago 21 club on July 9, 1988, following in the footsteps of Liberace, who had also gotten his start playing in area Polish bars according to local lore.

What is really central to this narrative, however, are the people. In researching this book, we have time and time again come across longtime residents characterizing Portage Park as "a 'neighborhood' neighborhood." What they mean to say is that the roots people have put down in the community stay. Whereas the average American household will typically move around every four years or so, it is not uncommon to find people who have lived here all their lives, sometimes since they or their parents first bought their home. Often their children will also look for a home in Portage Park, knowing full well the neighborhood's charm. The buildings are beautiful, but what really stands out is how out of these disparate elements of diverse ethnicities and creeds, bonds were forged out of which a community was born. This book is intended as a visual celebration of Portage Park's past and an opportunity to show off the amazing things right under our noses, and we think you will be surprised to find out what a rich heritage the area really has.

Because the format of this book is a photograph essay of vintage pictures, there are many remarkable places in Portage Park that we were unable to show. At the end of the book you will find a handy guide to some of the more prominent places in Portage Park. The list of architecturally notable buildings was primarily compiled from the American Institute of Architects's *AIA Guide to Chicago* and the database of the Chicago Historic Resources Survey. We sincerely hope you enjoy perusing through this book as much as we did putting it together.

One

FIRST PEOPLES

Portage Park's first inhabitants were Native American tribes. There are records of the Chippewa, Ottawa, Pottawatomi, and Kickapoo Indians in the area, although it is known that many other groups would make this place home during their nomadic travels across the North American continent. The land that became Portage Park differed little from its surroundings, with isolated clumps of trees like islands in a monotonous sea of grasslands. The soil here, swampy and wet, was caused by the area's poor drainage. Thanks to the ridges along what are today Cicero and Narragansett Avenues and the level slope of the surrounding plains, every spring a giant lake would swallow up much of the area with the exception of a patch of higher ground at Irving Park Road and Cicero Avenue. Portage Park's older residents can still recount local lore about the man who sailed his boat to the old town hall at Six Corners to pay his taxes or the neighborhood's old moniker of "Frogtown." The marshy nature of the area made this an optimal path to portage through between the Chicago and Des Plaines Rivers since travelers could often paddle their way through the swamp. Local legend Ralph Frese maintains that this was the portage chosen by the two French explorers Fr. Jacques Marquette and Louis Jolliet as they made their way through the Chicago area in September 1673.

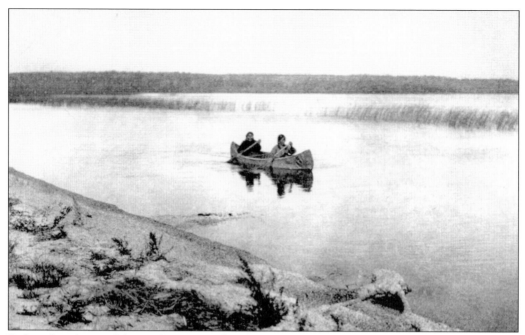

Before the advent of the modern age with railroads, cars, and airplanes, it was water that served as the primary mode of travel for all peoples the world over. Seen here is a picture of Native Americans canoeing, a scene that was not uncommon in the Chicagoland area before they were forced across the Mississippi River in 1837 as a result of the Black Hawk War.

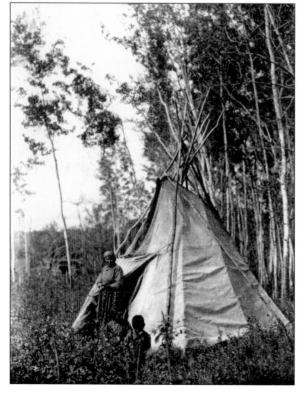

Chicago has always been at the crossroads of itinerant travelers, and the nomads of the Great Plains were known to have made their way through the Chicagoland area in their journeys across the North American continent.

Two

LIFE ON THE PRAIRIE

With the erection of Fort Dearborn in 1803, change was afoot, and what had seemed to be a timeless cycle came to a halt. A 20-mile-wide strip of land whose northern edge can still be made out by tracing the course of Forest Preserve Drive and Rogers Avenue was ceded to the U.S. government. Although most of Portage Park was included in this strip, which had been opened to settlement in 1830 with some squatters settling even earlier, substantial settlement was discouraged by the threat of Native American retaliation. It was not until Native Americans were expelled in 1837 onto the other side of the Mississippi River as a result of the Black Hawk War that colonists began to put down roots in the area. The story of Portage Park begins with the inn of E. B. Sutherland, who shortly later sold his establishment, located roughly where Milwaukee Avenue and Belle Plaine Avenue intersect today, to Chester Dickinson. Dickinson's tavern was where residents organized Jefferson Township, a large tract covering the area between Western and Harlem Avenues and between Devon and North Avenues. The tavern was the hub of local activity, serving as the area's post office and even as the town hall for a time. According to local legend, it was a frequent stop for both Abraham Lincoln and Stephen Douglas in their travels through the area. Despite the wet soil, the proximity of Chicago encouraged farmers to settle here because of the opportunity it presented. Beginning with homesteaders of British descent, the area became populated by German, Scandinavian, and later Polish farmers. Portage Park became the rustic heartland of Jefferson Township.

The oldest structure in the city at the time it was demolished in 1929, the Dickinson Tavern developed a wealth of legends and stories about the beginnings of this neighborhood. Travelers would often stay the night at the inn while en route to the city. Local tradition maintains that both Abraham Lincoln and his rival Stephen Douglas were frequent guests at the tavern during their many travels across Illinois. (Courtesy of the Chicago Historical Society.)

Here is a shot taken from a collection of photographs of the first settlement in the Austin-Irving area of Portage Park, the Martin Luther College subdivision. Seen is the endless prairie that early settlers encountered in what was then a rural area. (Courtesy of the Portage Park Center for the Arts.)

This photograph is of the vicinity around what is today Irving Park Road near Central Avenue at the beginning of the 20th century. A far cry from the hustle and bustle of city life, this shot could be mistaken as a view of almost any other part of the Midwest's rustic heartland. (Courtesy of the Portage Park Center for the Arts.)

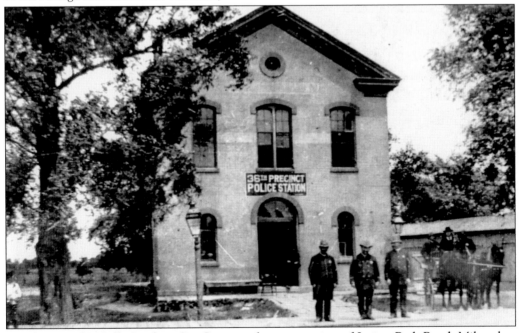

On the site of LaSalle Bank at Six Corners, the intersection of Irving Park Road, Milwaukee Avenue, and Cicero Avenue, once stood the town hall for Jefferson Township. Taking over this function from the Dickinson Tavern, this was the seat of government from the time it was built in 1862 until Jefferson Township was annexed in 1889. This shot features the old town hall functioning as the area police station. (Courtesy of the Irving Park Historical Society.)

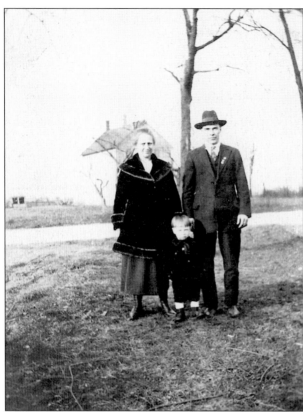

Life on the prairie was full of hopes and dreams for the families who saw in these empty lots an alternative to the congested city life they left behind. In 1920, 60 percent of all families in the Portage Park area owned their own homes, more than double the average for all of Chicago, which was only 25 percent. (Courtesy of John Sowizrol.)

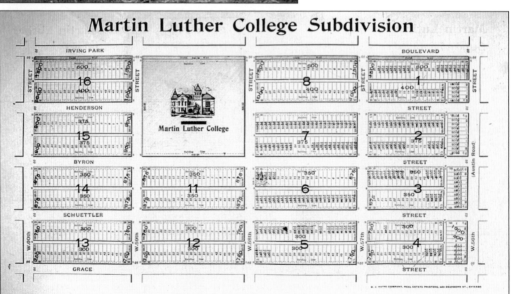

An 80-acre tract of land was purchased in 1893 off Irving Park Road between Central and Austin Avenues by Swedish Lutherans for the Martin Luther College subdivision. In addition to the college, there were plans for a church as well as lots for homes. Because of its remote location, the college moved to Rock Island, where it is now known as Augustana College. (Courtesy of the Portage Park Center for the Arts.)

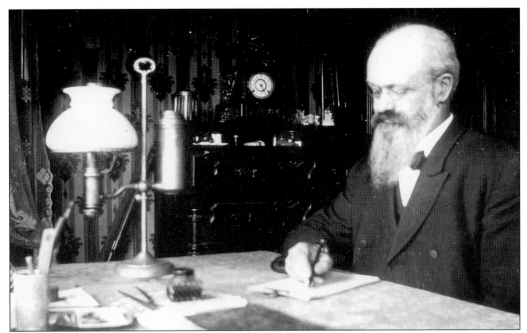

This is a picture of Ed Edstrom, one of the founding members of the Martin Luther College subdivision. This was the first development in what had been Portage Park's rural center. Before this, urban settlement had only taken place along Portage Park's edges as the older communities surrounding Portage Park expanded in. (Courtesy of the Portage Park Center for the Arts.)

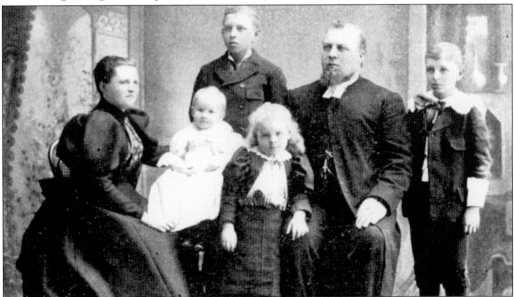

Rev. Sven Sandahl came to the Austin-Irving area in 1901 to help save the faltering Martin Luther College subdivision. The plans to build a Lutheran community around the college suffered after the school left the area, with poor transportation further discouraging families from relocating. However, the pastor brought back momentum for the project, and by 1902, the first building of the Nebo Swedish Evangelical Lutheran Church was dedicated. (Courtesy of the Portage Park Center for the Arts.)

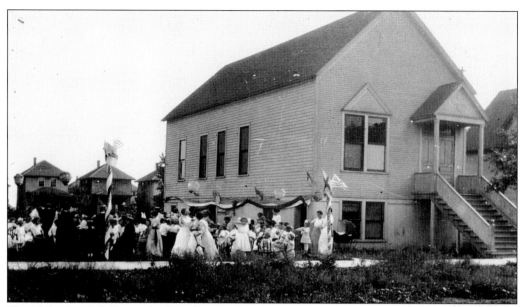

The Nebo Swedish Evangelical Lutheran Church is seen in this photograph from 1913, showing the original church built in 1902 that existed on the land. In this picture is a parish picnic, a means used by many communities throughout the area for fund-raising toward everything from church improvements to aid for their countrymen back home. (Courtesy of the Portage Park Center for the Arts.)

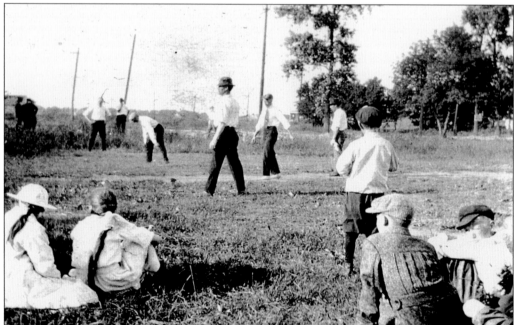

In 1906, Rev. Sven Sandahl began organizing annual Fourth of July celebrations. Taking place in this ball field at Menard and Berenice Avenues, residents would bring food while some men went house to house asking for small donations. Everyone would gather together for a jolly picnic to watch the fireworks display, and throughout the night, neighbors would sing in both English and their respective native tongues. (Courtesy of the Portage Park Center for the Arts.)

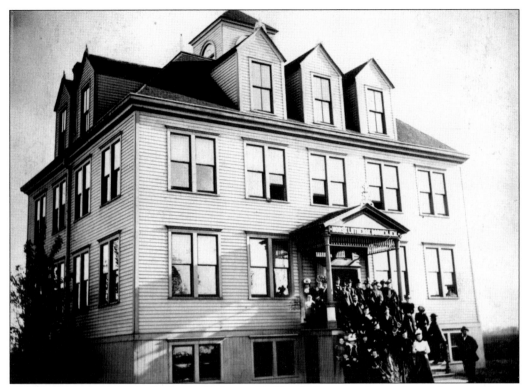

The building that originally housed Martin Luther College was located on what would now be the southwest corner of Irving Park Road and Menard Avenue. After the college relocated, the building became an orphanage. Today the property is a parking lot for the nearby Jesuit Millennium Center, a mission for Polish Catholics with a shrine dedicated to the Madagascar missionary blessed Jan Beyzym. (Courtesy of the Portage Park Center for the Arts.)

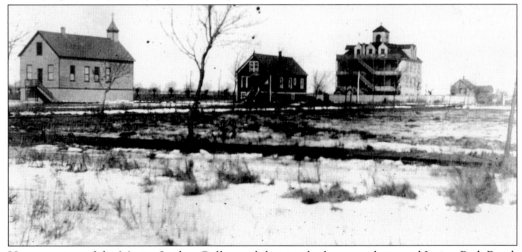

Here is a view of the Martin Luther College subdivision looking north toward Irving Park Road. The original Nebo Swedish Evangelical Lutheran Church can be seen on the far left next to where Menard Avenue and Dakin Street intersect today. Aside from two homes and the orphanage housed in the former Martin Luther College, the setting is all prairie as far as the eye can see. (Courtesy of the Portage Park Center for the Arts.)

A view of the back of the grounds of Nebo Swedish Evangelical Lutheran Church is seen here. Lines of outhouses stood here to give churchgoers the opportunity to take care of one of their most basic needs. Notice the presence of wooden walkways used to help prevent bringing mud indoors after making a quick trek outside. (Courtesy of the Portage Park Center for the Arts.)

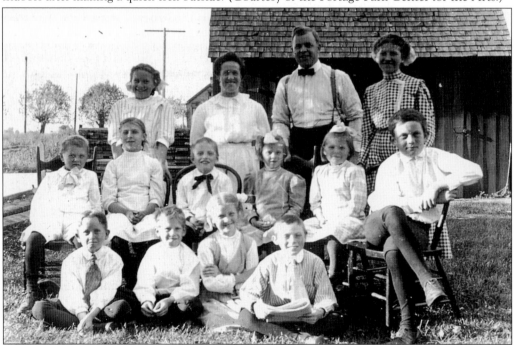

Here is a shot of residents of the Martin Luther College subdivision. It was the quality of idyllic scenes like this that lured families of all different backgrounds to then rural Portage Park. Searching for a contrast to the congested city center, the open space made up for the poor transportation and ever-present mud that characterized the area at the time. (Courtesy of the Portage Park Center for the Arts.)

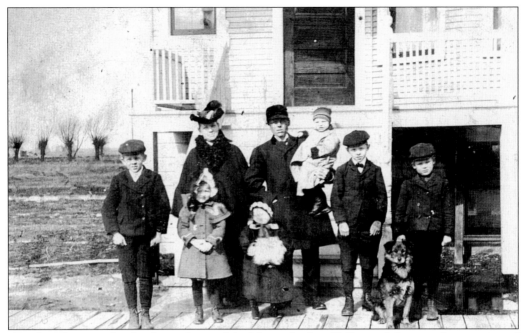

Another photograph of early residents of the Martin Luther College subdivision shows a view of nothing but prairie. This shot of a wooden frame house, plank sidewalks, and a large family fits the description of life for most early-20th-century residents throughout Portage Park. (Courtesy of the Portage Park Center for the Arts.)

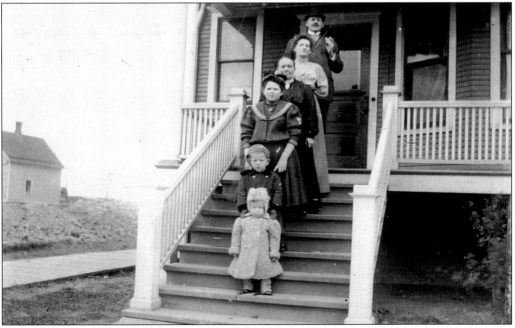

In this rural environment where land was both cheap and plentiful, it made sense to carry on the Old World tradition of gardening to provide additional money and food for the household. Pictured is a family shot from the collection of Martin Luther College subdivision residents. (Courtesy of the Portage Park Center for the Arts.)

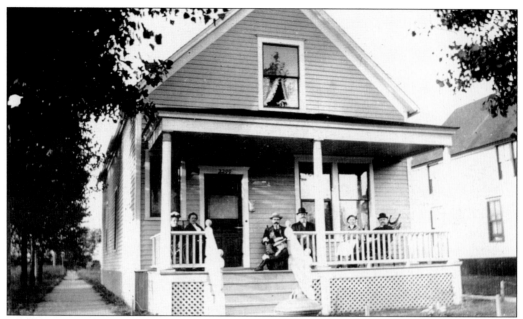

Sorting out the mess after Chicago's great annexation in 1889 made it necessary to implement a new system used for rendering street addresses. The 1908 ordinance made State and Madison Streets the two baselines from which all numbering began, changing numerous addresses in the city. The Swansons' residence at 2299 West Dakin Street when the photograph was taken in 1907 became 5858 West Dakin a year later. (Courtesy of the Portage Park Center for the Arts.)

This photograph, taken in 1907, shows one of the first homes in the community that was located at the corner of what is today Byron Street and Menard Avenue. These views highlight the rural quality of Portage Park's heartland, which endured despite being surrounded by older communities such as Dunning, Jefferson Park, Belmont-Cragin, and Irving Park. (Courtesy of the Portage Park Center for the Arts.)

This lovely Victorian home at 5859 West Dakin Street was deeded over to Nebo Swedish Evangelical Lutheran Church in 1905 by a Mrs. Schnalger in her will. It was sold again in 1997 after Nebo consolidated with seven other Lutheran churches on the northwest side of Chicago to form United in Faith Lutheran Church, located in Dunning right next door to the Jolly Inn. (Courtesy of the Portage Park Center for the Arts.)

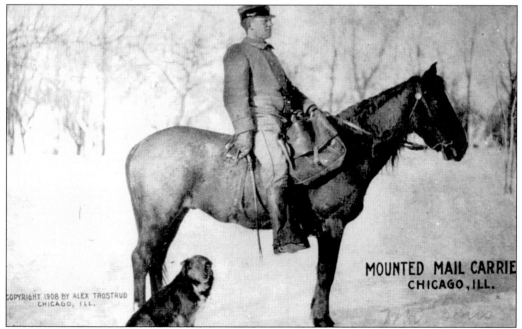

Here is a picture of a mounted mail carrier from 1908. Delivering mail on horseback was a necessity for rural letter carriers, who typically worked routes in low-density areas where dirt roads were the norm. (Courtesy of the Portage Park Center for the Arts.)

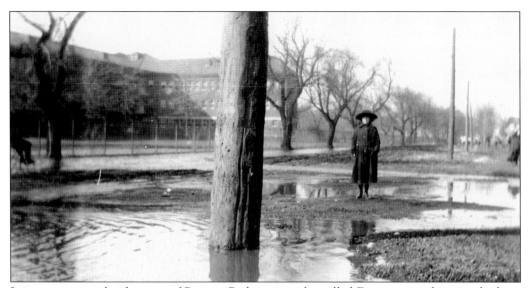

It is easy to see why this part of Portage Park came to be called Frogtown in this view looking north along Narragansett Avenue just past Irving Park Road showing just how extensive flooding once was throughout the area during spring. An early area resident reminisced that "as kids we used to go along the drainage ditches all the way to Milwaukee Avenue looking for crabs." (Courtesy of Ralph Frese.)

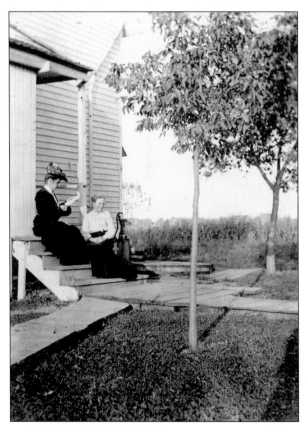

Here is a photograph of two residents of a home in the vicinity of Milwaukee Avenue. This view of these two ladies relaxing on the porch makes it easy to see that life in Portage Park at the time was about enjoying the pleasantries of wide-open spaces. (Courtesy of the Jefferson Park Historical Society.)

Another suburban view of the same house is shown here. While by no means dense, development is slowly taking off as more homes begin to populate the landscape. (Courtesy of the Jefferson Park Historical Society.)

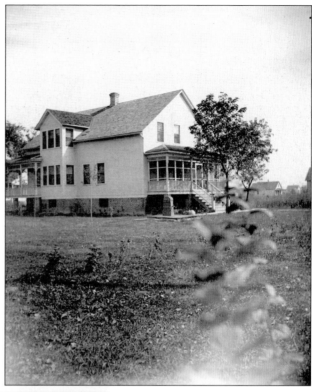

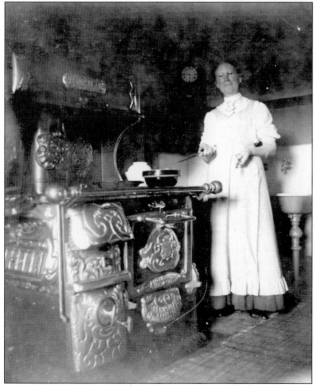

This is a view inside the same home. Many of the settlers in Portage Park were foreign-born immigrants, such as the members of this Polish American household. Photographs like this one were taken to show off to their loved ones back in the old country the good life they had achieved for themselves here. (Courtesy of the Jefferson Park Historical Society.)

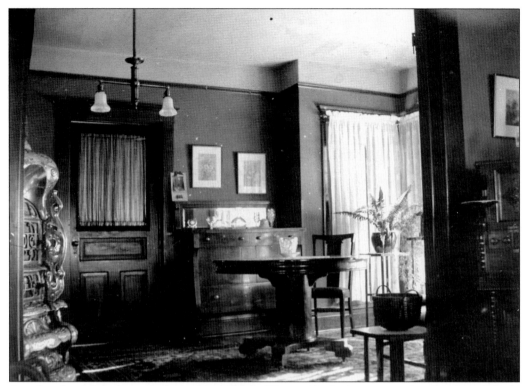

Another shot of the home is shown here. While life outside the home was often harsh with little or no urban infrastructure in the area, inside, one could cozily enjoy all the comforts in a living space almost twice the size of most dwellings in the city at that time. (Courtesy of the Jefferson Park Historical Society.)

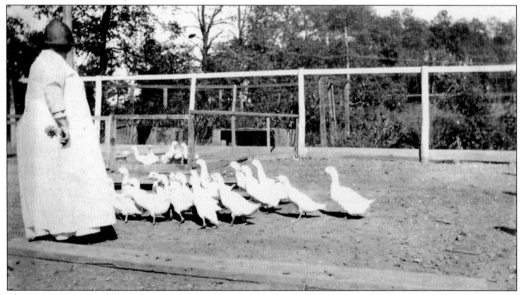

This scene unmistakably brings home the essentially rural character of Portage Park at the time. This is a view of Anne Lambin's miniature farm with a team of ducks waiting to be fed. Wilson Park is on the site of Lambin's farm today. (Courtesy of Royna Johnson.)

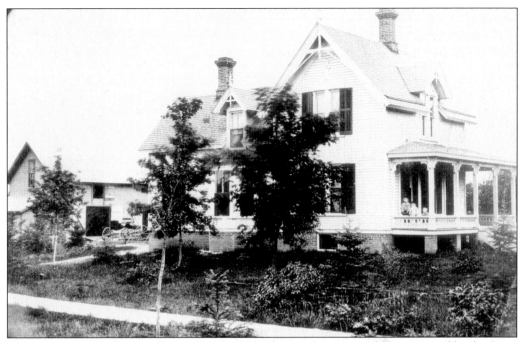

This is a view of the home of James Smith. In the future, this site would be occupied by the Sears complex at Six Corners designed by Nimmons, Carr and Wright. (Courtesy of the Chicago Public Library, Special Collections and Preservation Division.)

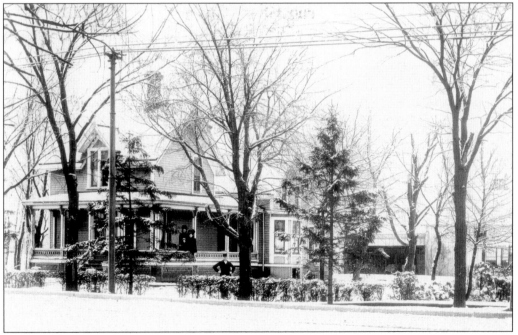

Another view of the James Smith home is seen here. This country scene would not last for long as in the near future developers saw the opportunity to turn a quick buck as Chicago's population soared and the need for housing for all its new inhabitants became more acute. (Courtesy of the Chicago Public Library, Special Collections and Preservation Division.)

This image is a scenic view of Milwaukee Avenue in days gone by. This 1890s Queen Anne at 4705 Milwaukee is currently highlighted on the Chicago Historic Resources Survey database with an orange designation, the second-highest ranking given by the city in evaluating the architectural and historical significance of a given property. Designed according to plans drawn

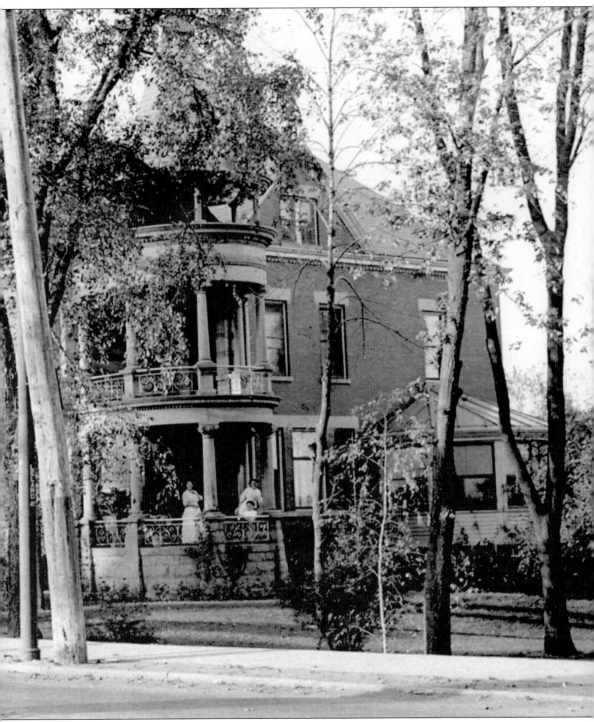

up by architect Otto Kaiser, this structure would fit right in among the luxurious graystones Lincoln Park is so well known for. Only three buildings in Chicago designed by Kaiser, active at the end of the 19th century, are known to have survived. (Courtesy of the Jefferson Park Historical Society.)

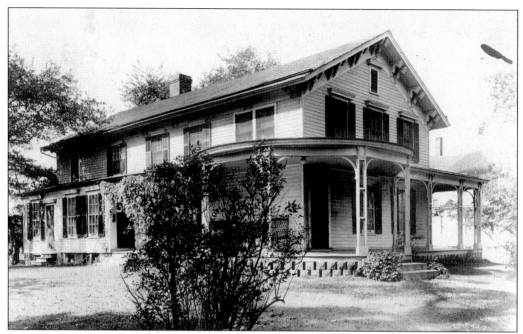

An old country home is seen at what is today 4564 North Milwaukee Avenue in the vicinity of Wilson Park. Life in Jefferson Township with its wide-open spaces stood in sharp contrast to life in Chicago's crowded tenements where most of the city's new arrivals lived. (Courtesy of the Chicago Public Library, Special Collections and Preservation Division.)

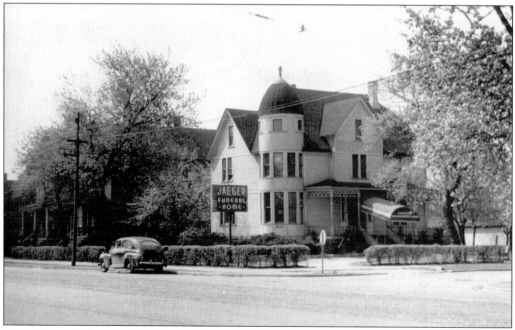

Jaeger Funeral Home at 3526 North Cicero Avenue claims to be the oldest continually operating funeral home in Chicago, having opened its doors at its first location in 1858. Businesses followed people into Portage Park and thrived as the area developed. (Courtesy of Jaeger Funeral Home.)

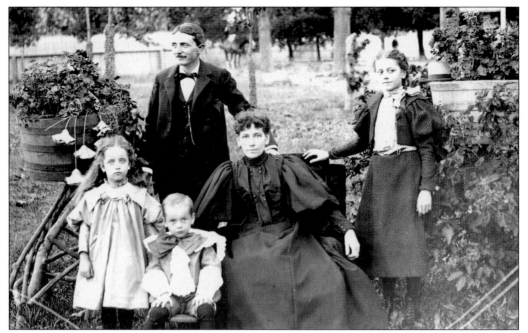

Another prominent family in Portage Park was the Kolzes, pictured here in this photograph from 1898. Coming to the area in 1835 from Germany, the family opened a tavern and post office in 1880 at Narragansett Avenue and Irving Park Road. A neighborhood legend, "Kolze's Grove," as locals dubbed the picnic grounds, was a popular gathering spot for locals and visitors alike. (Courtesy of the Sulzer Regional Library Historical Room, Chicago Public Library.)

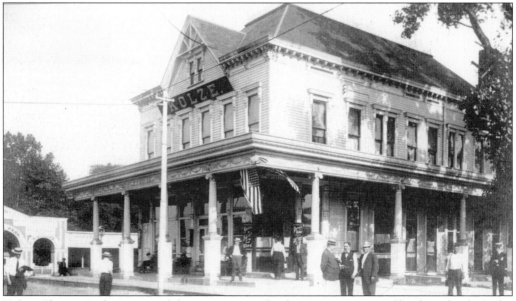

Kolze's Electric Park was one of the many names for the nine-acre tract of land run by the Kolze family at Irving Park Road and Narragansett Avenue. The moniker's origins are in the grove's claim to fame as the first establishment in the area to enjoy electricity. Countless Portage Park institutions, churches, and organizations used the grounds to raise money through fund-raising festivities. (Courtesy of the Sulzer Regional Library Historical Room, Chicago Public Library.)

This view shows Kolze's Grove. In 1948, the city acquired the grounds for use as a park and promptly razed the dance shelter, concession stands, raffle tables, and cafeteria. Out of 20 buildings on the site, the only one left standing was the original clapboard tavern as the park's new field house until a new brick facility was erected in 1969. Merrimac Park still occupies the site today. (Courtesy of the Sulzer Regional Library Historical Room, Chicago Public Library.)

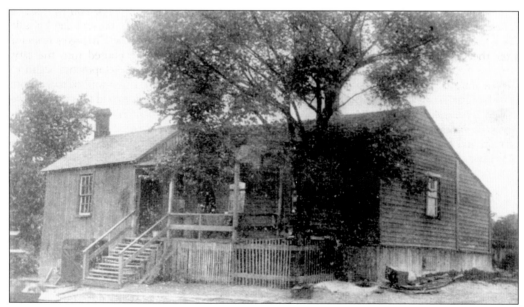

Pictured here is a shack located in the vicinity of where Milwaukee and Berteau Avenues intersect today. Built in 1847, this farmhouse structure gave way to commercial development as the Six Corners area was transformed from prairie farms into an outpost of city living. (Courtesy of the Chicago Public Library, Special Collections and Preservation Division.)

Three

Up, Up, and Up

In the latter half of the 1800s, urban sprawl began making its presence felt in Jefferson Township. With the construction of the forerunner to Milwaukee Avenue, the Northwest Plank Road for $51,000, the foundations were laid for expansion of the growing Chicago metropolis in the direction of Portage Park. This change of pace did not sit well with the area's rural populace, which was quite content to keep things the way they were. An attempt by the Chicago and Northwestern Railroad to construct a route through Six Corners in the 1850s was shelved due to villagers' opposition. When the railroad was finally constructed along its present route east of Cicero Avenue, development followed the improved access to the city center. The city's expansion was good business for those profiting from feeding its inhabitants, and by 1862, a permanent town hall for Jefferson Township was built at the location of present-day LaSalle Bank at Six Corners. Yet in the wake of the immense population growth that Chicago witnessed after the Civil War as immigrants from southern and eastern Europe poured into the city, pressure began to build to settle previously rural areas. Small suburban developments began to dot the landscape of Jefferson Township, slowly displacing farmers who often walked away quite wealthy. The annexation of Jefferson Township to Chicago in July 1889 turned this trickle into a flood as an influx of development and land speculators sought out their chance to strike it rich. With the extension of streetcar lines into Portage Park, the area transformed from one of genteel suburbs and farms into an urban neighborhood. Seemingly overnight, the prairie was now a part of the big city.

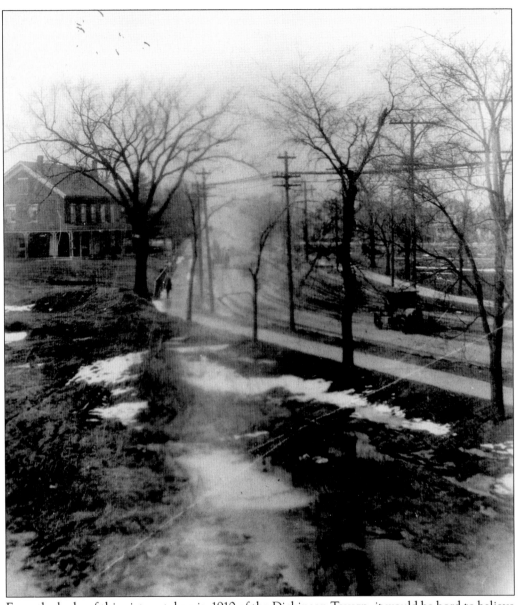

From the looks of this picture taken in 1910 of the Dickinson Tavern, it would be hard to believe that a mere 30 years later this would be part of the largest commercial district in Chicago outside of the Loop. The future site of the Portage Theatre can be seen here in the foreground. (Courtesy of the Irving Park Historical Society.)

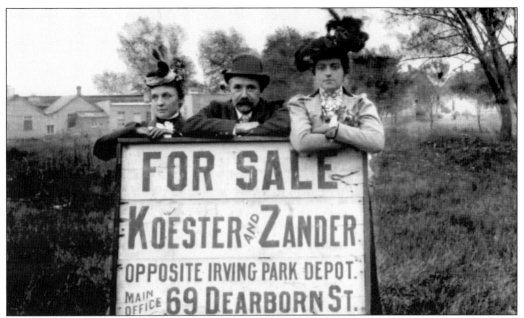

Every history dealing with Six Corners or Portage Park always goes back to Koester and Zander. Sensing an opportunity to turn a quick buck, they launched the first major real estate transaction in the area in 1889. With their purchase of 82 acres of land on the southwest corner of Irving Park Road and Cicero Avenue for $132,000, they developed part of what was once the William Gray farm. (Courtesy of the Irving Park Historical Society.)

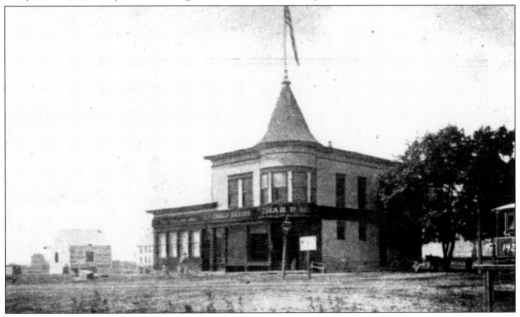

The first building to be constructed at Six Corners was the Borovik Drugstore at 3958 North Cicero Avenue, at the southwest corner of Cicero and Irving Park Road. Part of the building dates from the 1860s; however, the exact date of its construction is unknown. Formerly a tavern and coach stop, the building still stands today without the spire and flagpole above the corner. (Courtesy of the Irving Park Historical Society.)

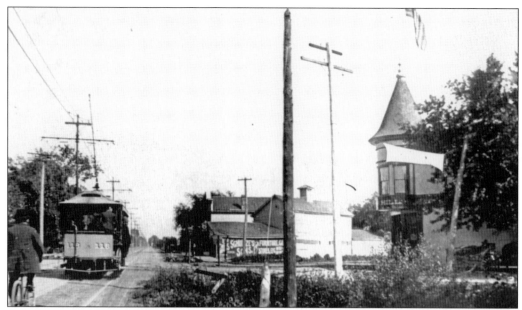

Another view of the Borovik Drugstore is seen here. Originally immigrants from Russia, the Boroviks relocated their business from farther in the city, operating this neighborhood fixture for 75 years. Eunice Borovik was the longtime president of the Portage Park Chamber of Commerce, and her son George still serves as its executive director. A branch of Washington Mutual currently operates out of this building. (Courtesy of the Irving Park Historical Society.)

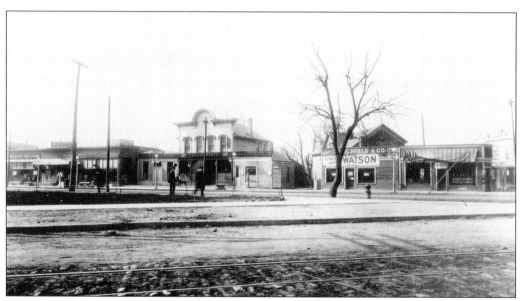

Here is a photograph of Six Corners along Cicero Avenue with a view of Paul Fabisch's restaurant, Marek's Home Trading Store, and the Logan Tea Company. This shot shows the rapid commercial development brought by the expansion of streetcar lines along Milwaukee Avenue, Cicero Avenue, and Irving Park Road, giving shoppers easy access to the area. (Courtesy of the Chicago Public Library, Special Collections and Preservation Division.)

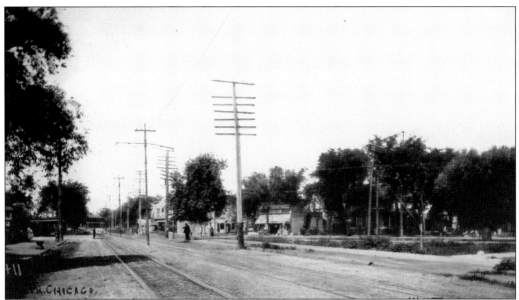

Here is another view of Six Corners with the streetcar tracks along Milwaukee Avenue plainly visible. It was the expansion of streetcars into this area that made Portage Park's commercial and residential development possible. The Irving Park Road line was begun by 1896, the Milwaukee line reached Lawrence Avenue a decade later in 1906, and the Cicero Avenue line was extended north from Madison Street to Irving Park in 1913. (Courtesy of the Irving Park Historical Society.)

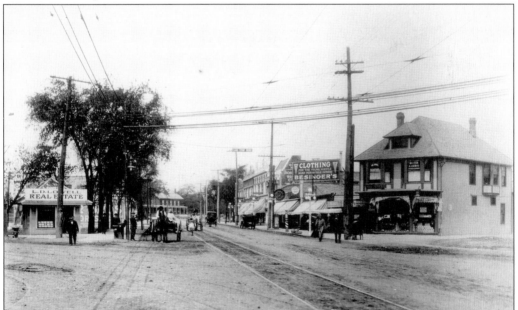

Legend has it that the jog along Milwaukee Avenue, seen here in the background next to the Dickinson Tavern, came about as a token of thanks from grateful surveyors. While laying out the street, they were treated to a feast by Chester Dickinson, the tavern's owner, and returned the favor by bringing traffic right to his doorstep. (Courtesy of the Chicago Public Library, Special Collections and Preservation Division.)

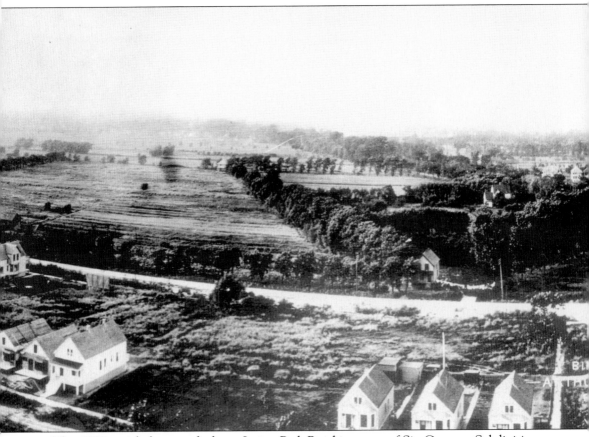

This 1909 aerial photograph shows Irving Park Road just west of Six Corners. Subdivisions are beginning to take shape from the farmland as the district begins to transform into more of a suburban landscape. Developer Arthur W. Dickinson had this picture taken from a kite to get a shot of the whole area. The outlines of the Borovik Drugstore can be made out on the far

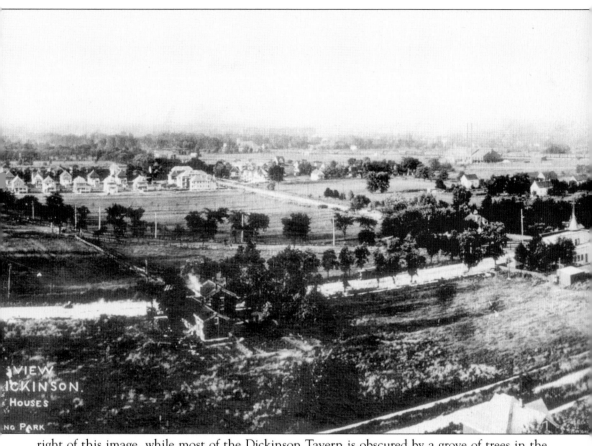

VIEW
ICKINSON,
HOUSES

NG PARK

right of this image, while most of the Dickinson Tavern is obscured by a grove of trees in the middle of the picture save for part of its porch. (Courtesy of the Chicago Public Library, Special Collections and Preservation Division.)

The Dickinson family took notice of the real estate frenzy at Six Corners, as seen here. Developer Arthur W. Dickinson, along with George F. Koester, was responsible for convincing local residents to name the area's park district Portage Park after the old Native American portage along Irving Park Road. (Courtesy of the Chicago Public Library, Special Collections and Preservation Division.)

This view shows the corner of Milwaukee Avenue and Hutchinson Street. West Irving Park, as this part of Portage Park was then referred to, was experiencing a commercial boom that transformed this stretch of prairie into part of the urban fabric of Chicago. (Courtesy of the Chicago Public Library, Special Collections and Preservation Division.)

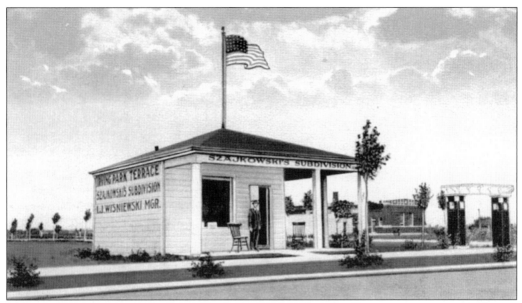

This postcard came from local developer Edmund Szajkowski. He was instrumental in luring in Poles from Polish Downtown to settle in Portage Park. At his own cost, he built a frame hall on Lockwood and Roscoe Avenues that enabled St. Wenceslaus Roman Catholic Church in Avondale to open a mission for Polish Roman Catholics in the area. With room for about 150 people, this mission was the start for what ultimately became St. Ladislaus Parish. (Courtesy of Frank Suerth.)

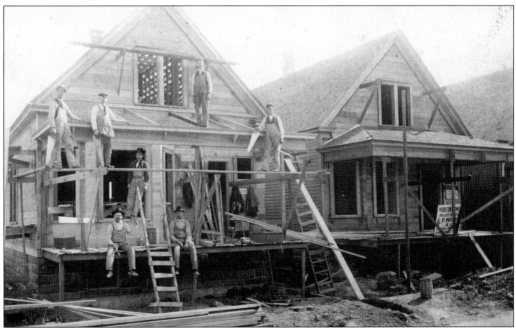

Swedish builders are at work building frame cottages in the Martin Luther College subdivision. At the same time that Western Irving Park and Six Corners began booming, the area around Nebo Swedish Evangelical Lutheran Church saw an influx of Swedes dispersing from the city center. (Courtesy of the Portage Park Center for the Arts.)

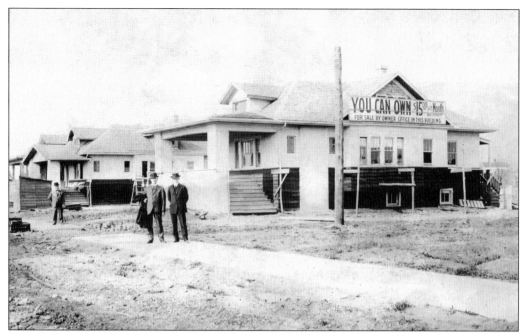

Prairie-style bungalows were popular in the neighborhoods that followed Milwaukee Avenue in Portage Park. This is a photograph taken roughly around 1910 of the 4600 block of Leclaire Avenue showing some of these bungalows in Portage Park under construction. (Courtesy of Veronica Kanarowski.)

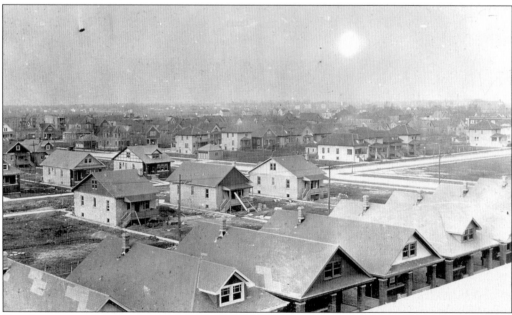

Development is picking up speed as literally whole neighborhoods are being completed on a massive scale. The rooftops seen in the lower right-hand corner are the Schorsch Irving Park Gardens Historic District, while the homes north of them are in the Martin Luther College subdivision. The "Bungalow Belt" is taking shape in Portage Park. (Courtesy of the Portage Park Center for the Arts.)

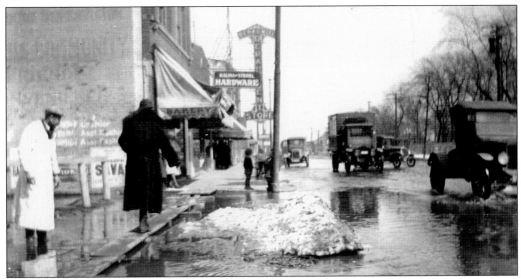

What made the area so convenient for travelers portaging through the area was a notorious problem for those choosing to settle here. This view shows Irving Park Road east of Narragansett Avenue. A familiar sight for early residents, Portage Park's flooding problems would only be alleviated with the installation of sewers throughout the area. (Courtesy of Ralph Frese.)

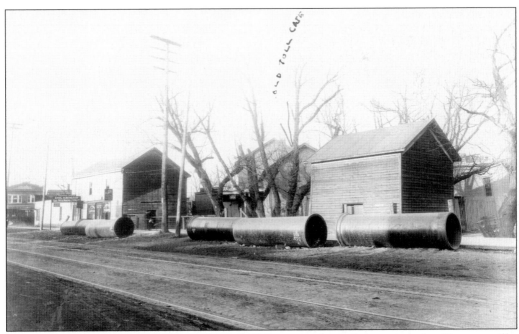

Even though the development boom showed all the signs of a modern society, flooding was still a problem in the area. Here sewer pipes are laid down at Six Corners on Cicero Avenue just south of Irving Park Road in 1912. In the background is Emil Bengson's coal and feed store, which started business with two horses and two dilapidated wagons. (Courtesy of the Chicago Public Library, Special Collections and Preservation Division.)

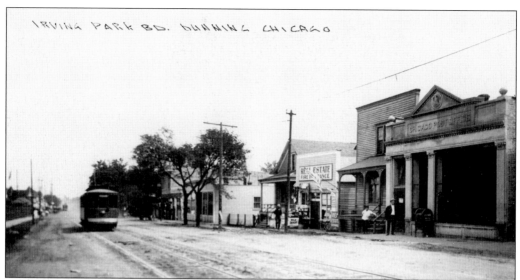

Here is a photograph of nearby Dunning just west of Portage Park with a view of the post office just west of Narragansett Avenue on Irving Park Road. The western fringes of Portage Park originally developed as an extension of Dunning, which grew thanks to its proximity to Chicago State Hospital as well as Mount Olive and Mount Mayriv Cemeteries. (Courtesy of the Jefferson Park Historical Society.)

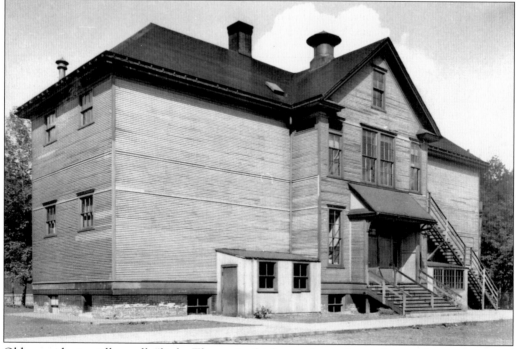

Older residents still recall "little Thorpe," which was located on the southwest corner of Narragansett Avenue and Addison Street. Local children attended classes here while attending the first, second, and third grades, after which they transferred to the Ole A. Thorpe grade school, located at Austin and Warwick Avenues. Apartment buildings currently occupy the site. (Courtesy of Ralph Frese.)

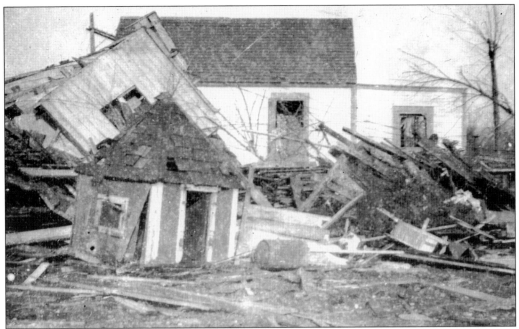

Most residents have forgotten about the 1920 tornado that ravaged Portage Park's Austin-Irving area. As seen in this picture, the storm hit the neighborhood particularly hard. The heaviest losses were suffered by the farmers still residing in the vicinity, their farmhouses and machinery left in ruins. (Courtesy of the Portage Park Center for the Arts.)

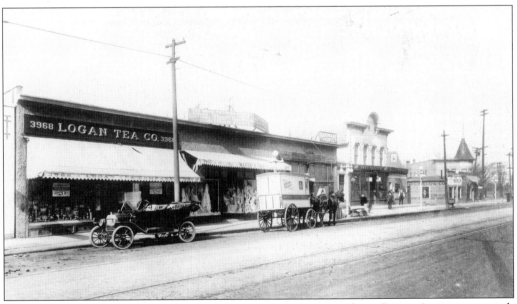

What a difference a century makes in this view of Six Corners along Cicero Avenue just south of Irving Park Road. On the far right is the Borovik Drugstore, followed by Fabisch's Restaurant, Marek's Home Trading Store, and the Logan Tea Company. A local nickelodeon, the Grayland, was located just outside the picture at 3940 Cicero Avenue. (Courtesy of the Chicago Public Library, Special Collections and Preservation Division.)

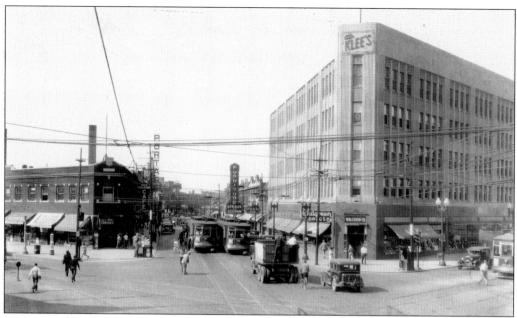

With the addition of the art deco Klee Building, this view of Six Corners from 1934 has begun to take on a shape very familiar to passersby today. From this shot, taken looking northwest, one can make out not only the Portage Theatre but also the building complex that replaced the Dickinson Tavern, razed in 1929. (Courtesy of the Chicago Public Library, Special Collections and Preservation Division.)

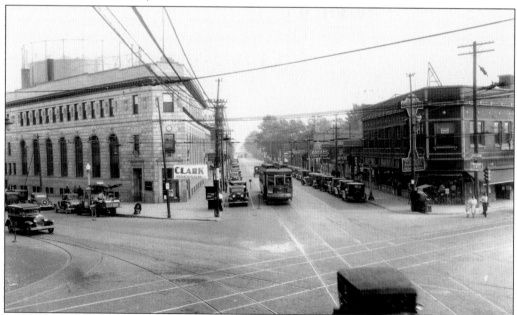

Another view of Six Corners in 1934 looks southeast along Milwaukee Avenue. The building on the left is the bank built on the site of the former town hall and police station. While the modern exterior of this building currently occupied by LaSalle Bank is unrecognizable, its interior still retains its elegant decor from this era. (Courtesy of the Chicago Public Library, Special Collections and Preservation Division.)

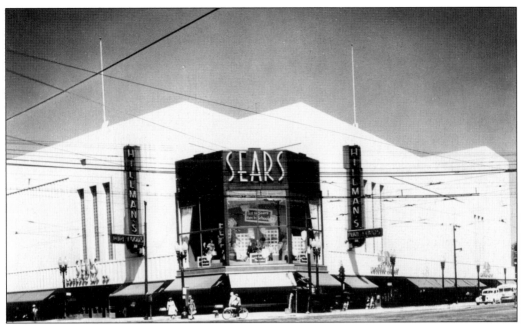

Sears opened its Six Corners location in 1938, built on the site of an old Greek candy store. One of a handful of prototype stores designed around the concept of showcasing merchandise, the company spent $1 million building this art moderne edifice. Designed by Chicago architects Nimmons, Carr and Wright, it was constructed of monolithic concrete with no brick or limestone used in the building's construction. (Courtesy of the Sears Holdings Historical Archives.)

One of Sears's first gigantic solid-walled stores, the Six Corners site incorporated the company's newest store design concepts from its store planning and display department. By carefully studying customers' habits, sales records, and other data over the course of years, the department developed this store design to optimally present store merchandise. (Courtesy of the Sears Holdings Historical Archives.)

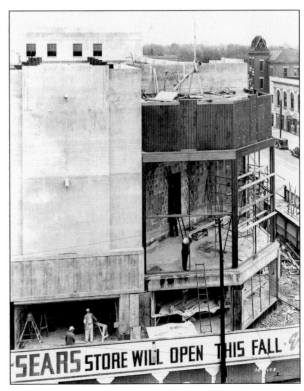

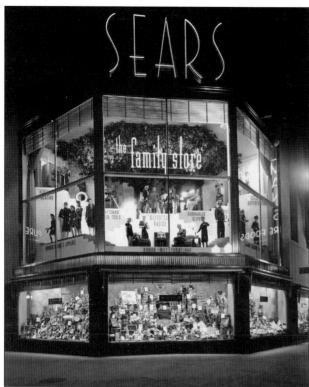

The 30-foot-high window display at the Six Corners Sears was the city's largest at the time of its construction. These display windows were used to showcase merchandise, functioning as transparent billboards for the store. These are the only windows found throughout the whole structure since designers found that artificial lighting was better suited for displaying the store's wares. Interestingly enough, the ground-level display windows are filled with groceries from the Hillman's Pure Foods occupying the store's lower level. (Courtesy of the Sears Holdings Historical Archives.)

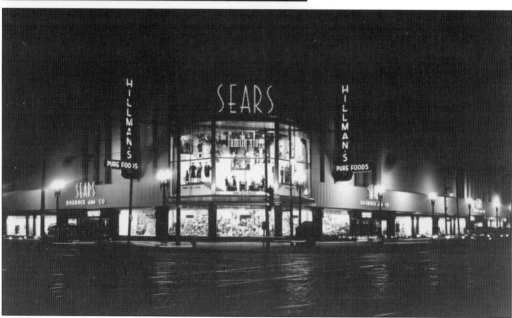

Unlike most department stores of the time, the Sears at Six Corners had air-conditioning, a sprinkler system, and escalators, as well as parking for 360 automobiles, leaving consumers with a shopping experience unseen outside of downtown. Hillman's Pure Foods, a grocery store, occupied the building's basement, with two marquees visible in this picture. (Courtesy of the Sears Holdings Historical Archives.)

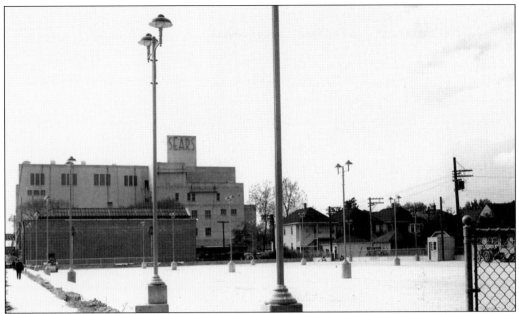

The Six Corners Sears saw crowds of almost 100,000 shoppers on opening day. But this was not the only large crowd the store experienced. During World War II, the store received a shipment of merchandise made scarce by the war effort. An "attacking force" of 15,000 shoppers stormed the store and wreaked such havoc that the *Chicago Tribune* wryly reported the event with the headline of "Invasion." (Courtesy of the Sears Holdings Historical Archives.)

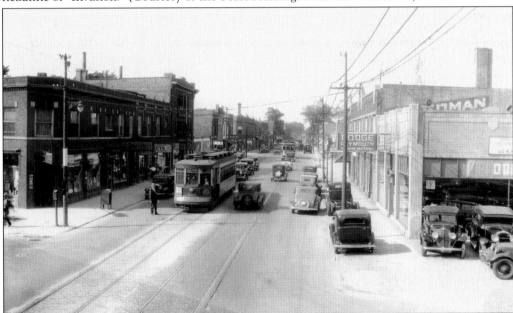

The intersection at Montrose Avenue is visible in the background of this northwest view of Milwaukee Avenue from Six Corners. The building on the left is currently the home of the Chicagoland Polish Phone Book, while the car dealership shown here is currently a Sherwin-Williams paint store. (Courtesy of the Chicago Public Library, Special Collections and Preservation Division.)

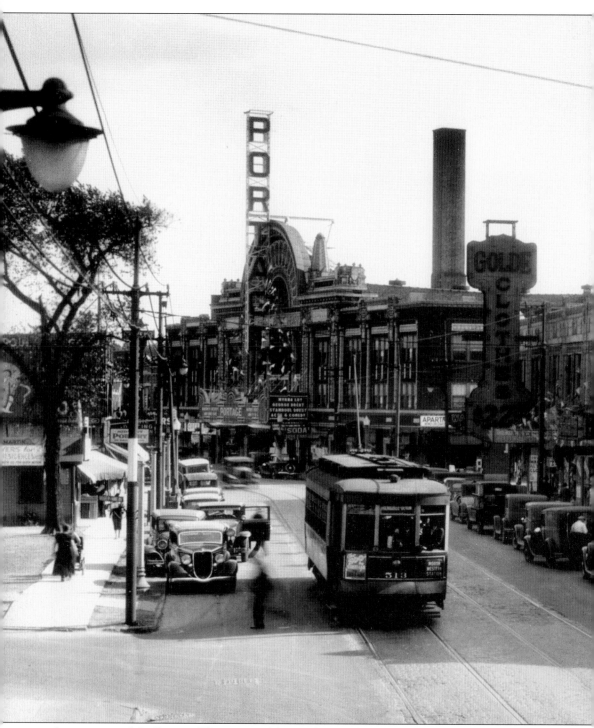

A panorama of the Portage Theatre, as older residents still remember it, is seen with its original marquee and ornate terra-cotta decor. One can also see the building that replaced the Dickinson Inn. Despite local attempts to save it, the structure was razed in 1929, and a plaque was installed on this art deco edifice to commemorate the historic site. Local legend Bernie Molay's father,

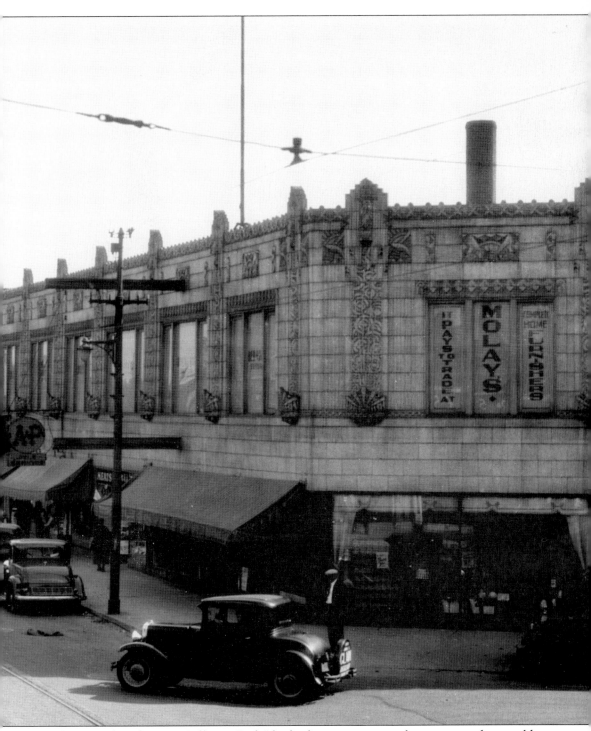

fondly remembered as "Mr. Jefferson Park," had a furniture store in this structure that would go bust during the Great Depression. The local merchant's sign is visible in the window closest to the right. (Courtesy of the Chicago Public Library, Special Collections and Preservation Division.)

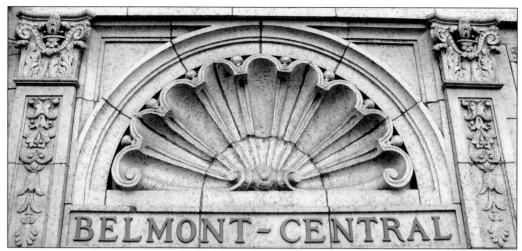

A magnificent detail from the Belmont-Central building at the heart of the Belmont-Central Business District is seen here. Recognizable for its ornate terra-cotta decorations, the classical revival structure was built in 1929. It was designed by John G. Steinbach of the architectural duo of Worthmann and Steinbach, the team that drew up plans for some of Chicago's most opulent "Polish Cathedrals," such as St. Hyacinth Basilica and St. Mary of the Angels.

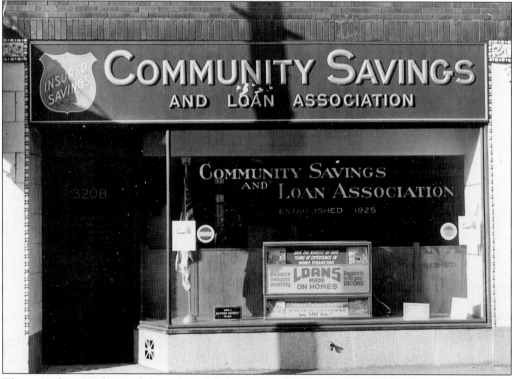

This was the storefront of the original Community Savings Bank at 3208 Cicero Avenue, just north of the street's intersection with Belmont Avenue. The bank opened its doors for business on September 21, 1944. It was just doors down from the Elinor Hotel, a property whose onetime elegance is still evident to passersby who care to casually walk through the hotel's main lobby. (Courtesy of Community Savings Bank.)

The Patio Theater was built in 1927 by Albert J. Schorsch according to a design by Rudolph G. Wolff. With seating for 1,500 people, it impressed patrons with its large twinkling ceiling and a powerful 4,000-watt spotlight originally from Chicago Stadium. The Patio is the subject of a film by Louis Antonelli called *The Wizard of Austin Boulevard*. The theater has been unused since the city closed it in 2001.

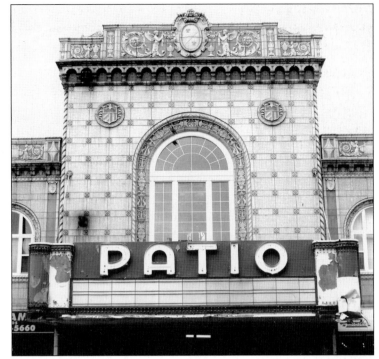

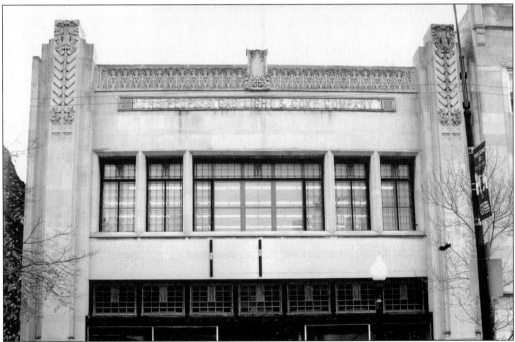

Another of Six Corner's wealth of art deco architecture is the People's Gas, Light and Coke Company building at 4839 West Irving Park Road, built in 1926. Recognized as a Chicago landmark, it is one of George Grant Elmslie's few surviving works. An assistant to famed architect Louis Sullivan, he designed a number of buildings for the People's Gas, Light and Coke Company.

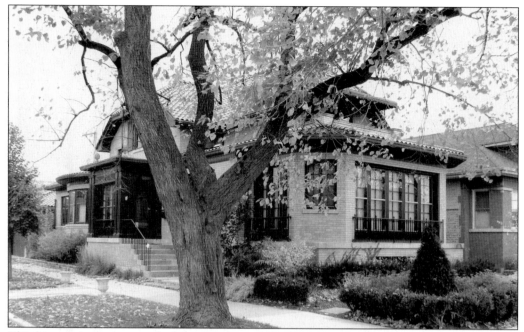

This historic bungalow was built by the team of Slupkowski and Piontek, most of whose work is found in Chicago's West Town community area. Clement L. Piontek is perhaps most well known for his role with Worthmann and Steinbach as part of the team that designed the breathtaking St. Nicholas Ukrainian Catholic Cathedral in Ukrainian Village.

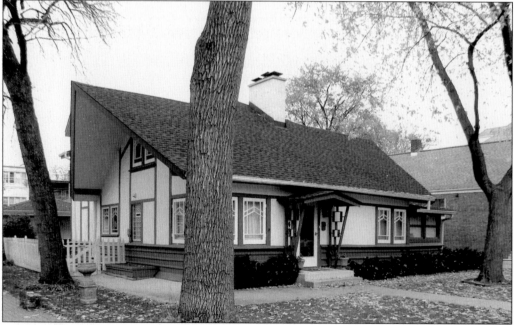

The Karl Stecher house at 4840 Pensacola Avenue, built in 1910, was designed by Walter Burley Griffin, who began his career with Frank Lloyd Wright and gained fame for his role in designing Canberra, Australia's capital. Griffin Place in Beverly is named in his honor in the Chicago landmark district that holds the largest cluster of small-scale Griffin designs still in existence.

Older Chicagoans still remember the Bowman Dairy, located just outside Portage Park at 4125 North Kostner Avenue. Providing milk to Portage Park residents and beyond, the company did brisk business until 1966, when it was bought out by Dean Foods. (Courtesy of Jane Ohlin.)

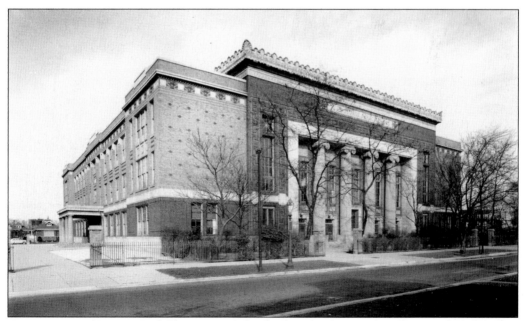

Here is a view of Portage Park Elementary School. The school was originally named after Wicker Park native Ole A. Thorp, but the neighborhood lobbied to have the school's name changed to Portage Park in a show of community pride. Another local elementary school would later bear Thorp's name. (Courtesy of Portage Park Elementary School.)

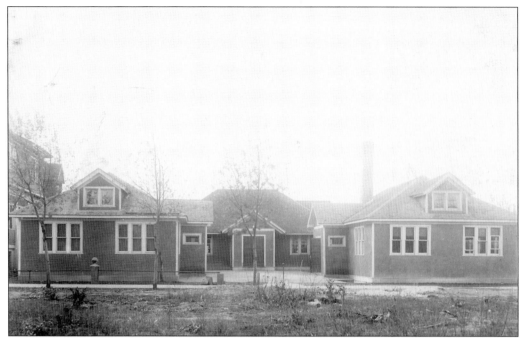

A design that could only be found in Chicago's "Bungalow Belt," this bungalow school building was built for Our Lady of Victory Roman Catholic parish on Sunnyside Avenue in 1919 for use as an elementary school. (Courtesy of Our Lady of Victory Roman Catholic Church.)

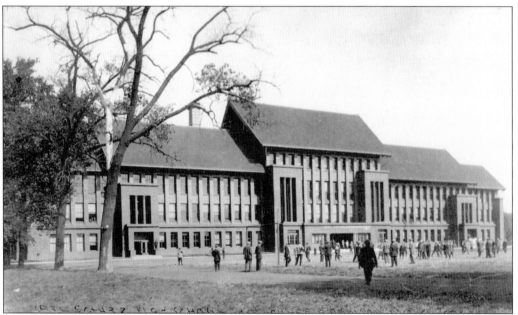

Successor to the school that was in the former Jefferson Town Hall, Carl Schurz High School in Irving Park was designed by Dwight Perkins and completed in 1910. A Chicago landmark, the school has been declared one of "150 great places in Illinois" by the American Institute of Architects. Few, however, are aware of Bowen High School on Chicago's southeast side, virtually indistinguishable from Schurz if not for Schurz's later additions. (Courtesy of Frank Suerth.)

Four

WORSHIP

Houses of worship were among the first buildings that incoming residents constructed as they settled Portage Park, a fact not lost on area developers like Albert J. Schorsch and Edmund Szajkowski, who donated lots to churches in a bid to drum up sales. Each group that settled here built sanctuaries that were meant to "last for the ages." The result is a diverse legacy both architecturally and theologically, with modest bungalow churches neighboring ornate temples and modern architectural structures. Certain locals claim that at one time the area was even home to a storefront synagogue. Portage Park's wealth of sacred spaces is constantly being enriched, such as with the opening of Chicago Ratna Shri Sangha by followers of Tibetan Buddhism and the Jesuit Millennium Center in the former Moose lodge with its shrine to blessed Jan Beyzym. It is a small wonder that Portage Park is one of Chicago's few North Side neighborhoods highlighted in the Spiritual Traveler's guide to Chicago and Illinois.

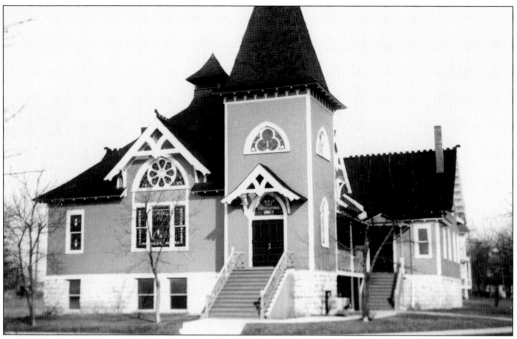

Jefferson Park Congregational Church was the first religious structure in the historical core of Jefferson Township. The church was founded just six days after the beginning of the Civil War, on April 18, 1861. Here is a picture of the second church building of the Jefferson Park Congregational Church. (Courtesy of the Jefferson Park Historical Society.)

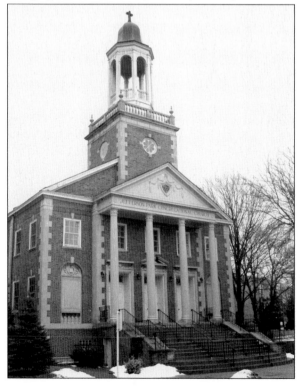

Here is a view of the current edifice of the Jefferson Park Congregational Church located at 5320 West Giddings Street. Ground was broken in 1927, and the building was in the final stages of construction in 1929 as the Great Depression began.

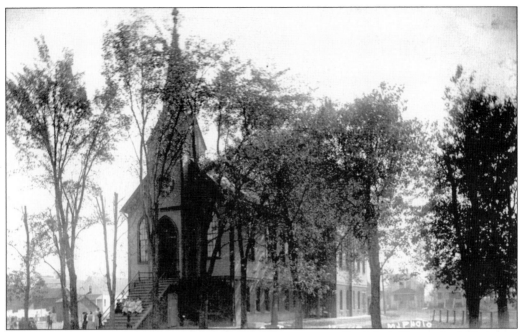

Pictured here is first building used by the St. Johannes, or St. John's Evangelical Lutheran Church as it is known today. Built in 1876, it was known to most locals simply as "the German Church" when it was founded. St. John's to this day still holds service in the German language every Sunday morning at 9:30. (Courtesy of St. John's Lutheran Church.)

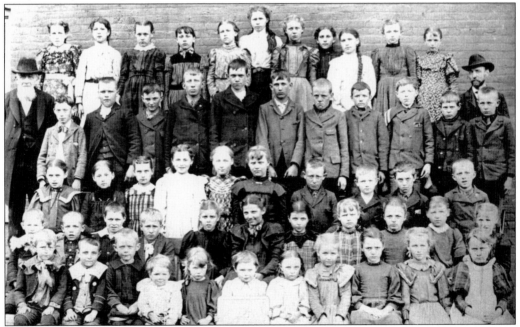

The children in this old photograph attended the St. John's school. The basement of the original church building doubled as both the school and parsonage before an additional building consisting of four classrooms, a basement playroom, and a heating plant was erected in 1915. (Courtesy of St. John's Lutheran Church.)

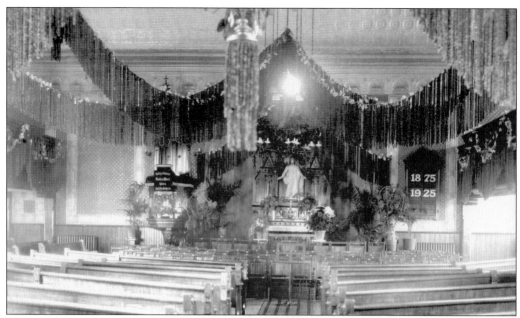

This is a view of the interior of the first church building used by St. John's Evangelical Lutheran Church. This picture is from just after the church had celebrated its 50th anniversary in 1925. In five short years, this house of worship would be gone, replaced by the current Gothic Revival structure still standing today at Montrose and Lavergne Avenues. (Courtesy of St. John's Lutheran Church.)

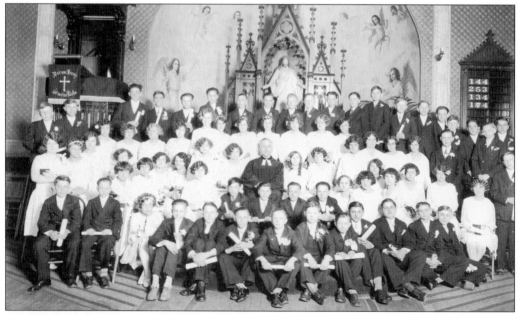

Religious education has always been one of the ways that kids from from all over the neighborhood met each other. This photograph is of the confirmation class of 1928 inside the old St. John's Evangelical Lutheran Church. There are 32 Lutheran schools in the city of Chicago, making it the most extensive private school network after the Roman Catholic Archdiocese of Chicago. (Courtesy of St. John's Lutheran Church.)

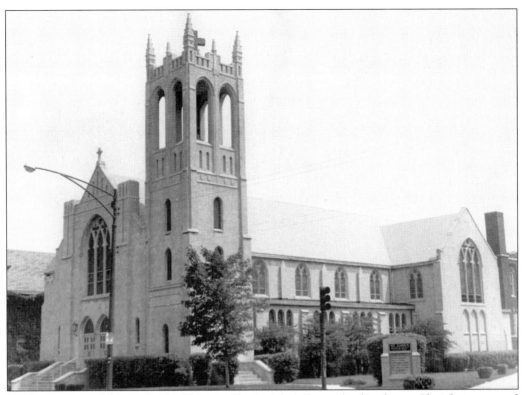

Here is a picture of the current building used by St. John's Evangelical Lutheran Church, its towered silhouette recognized by passersby traveling along Montrose Avenue entering and exiting off the Kennedy Expressway at 4939 West Montrose Avenue. Built of colored Indiana limestone, the main body of this Gothic Revival edifice is cruciform in plan, with the front facade dominated by a large traceried three-lancet stained-glass window. (Courtesy of St. John's Lutheran Church.)

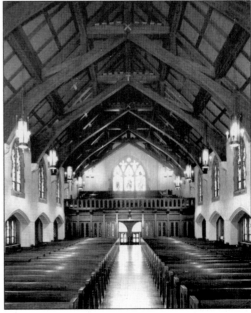

All who enter marvel at the elegant interior of St. John's Evangelical Lutheran Church. Upon entering the church, visitors' eyes are instantly drawn to the magnificent altar reredos and vaulted ceiling. This picture shows a view of the church looking north toward the choir before a new custom-built organ was installed as part of the congregation's 125th anniversary celebrations. (Courtesy of St. John's Lutheran Church.)

Here is a view of the old brick parsonage at St. John's Evangelical Lutheran Church, erected in 1958. The structure was built on the site where both of its two wooden predecessors had stood, the first built in 1887, the second in 1911. (Courtesy of St. John's Lutheran Church.)

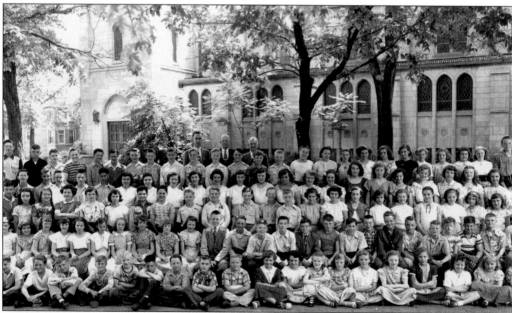

Taken from Lavergne Avenue, this group picture shows children alongside St. John's Evangelical Lutheran Church. The lower reaches of the church's tower can be made out above the side entrance. Churches played an important, if unacknowledged, role in aiding the different communities settling Portage Park to put down roots in the area, transforming immigrants into Americans. (Courtesy of St. John's Lutheran Church.)

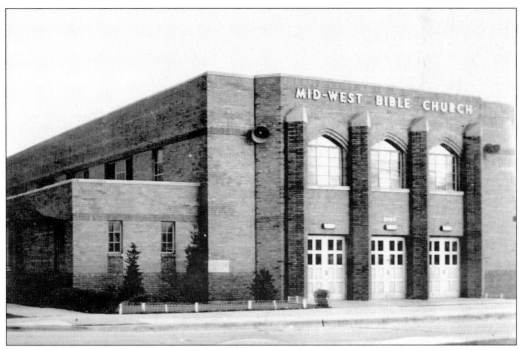

Here is a photograph of Midwest Bible Church from 1939. This building at 3469 North Cicero Avenue was originally used as the congregation's first church at this location. The structure still stands here today in use as part of Midwestern Christian Academy, the private school run by the church. (Courtesy of Midwest Bible Church.)

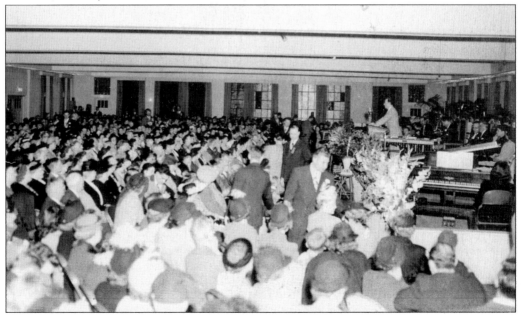

The service in this image was held at the second house of worship used by Midwest Bible Church at 3441 North Cicero Avenue. A former Packard automobile garage, the structure's roof caved in during the infamous "big snow" of 1979. The entire building was razed to make way for the building still in use today. (Courtesy of Midwest Bible Church.)

This is the first church building for Nebo Swedish Evangelical Lutheran Church, built in 1902. The community that sprang up around Nebo was the first residential neighborhood that was closer to the center of Portage Park instead of along its edges. Until then, the area's development "was like a pretzel," as one longtime resident put it, with older districts expanding into what is today Portage Park. (Courtesy of the Portage Park Center for the Arts.)

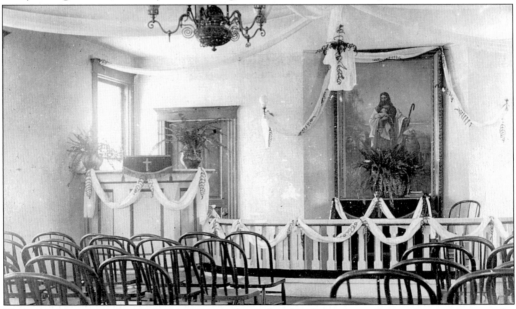

No matter how simple, each community created a familiar sense of sacred space, as can be seen in this photograph of Nebo Swedish Evangelical Lutheran Church. Shown is the original interior's layout of the simple wooden church on Menard Avenue and Dakin Street that was built by Rev. Sven Sandahl. (Courtesy of the Portage Park Center for the Arts.)

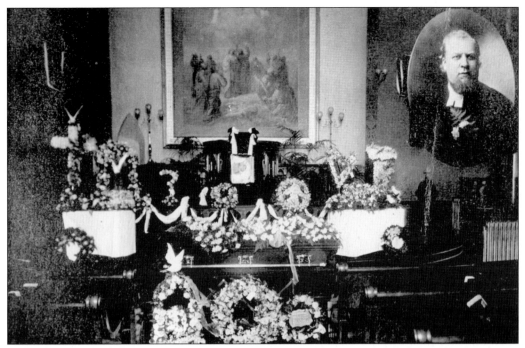

This is a picture of funeral services for the founding pastor of Nebo Swedish Evangelical Lutheran Church, Sven Sandahl, who died young in 1910. It was taken inside the old wooden church he helped build. Sandahl was succeeded at Nebo by M. C. Ranseen. (Courtesy of the Portage Park Center for the Arts.)

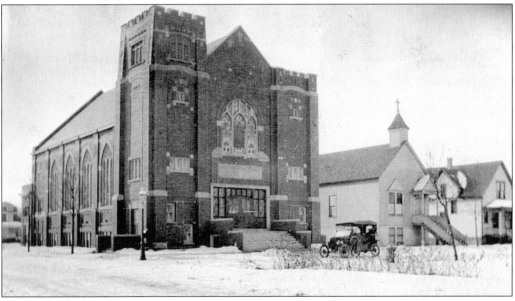

As communities grew and took root, so did their means to build a temple "fit for proper worship." Here is a shot of the first Nebo Swedish Evangelical Lutheran Church at 3914 North Menard Avenue alongside its successor church building erected in 1915. The first church would later be torn down to make room for a parsonage that stood on the site for years. (Courtesy of the Portage Park Center for the Arts.)

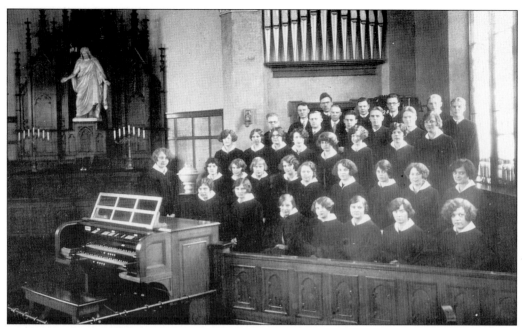

Music has a long tradition as an integral part of the experience of the sacred. Here is a view of the choir at Nebo Swedish Evangelical Lutheran Church. (Courtesy of the Portage Park Center for the Arts.)

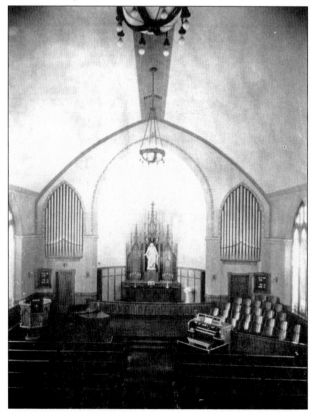

This is a photograph of the interior of Nebo Swedish Evangelical Lutheran Church just after it was first dedicated in 1915. The wooden altar shown here, albeit stripped of its religious statuary, is still present in the building today. (Courtesy of the Portage Park Center for the Arts.)

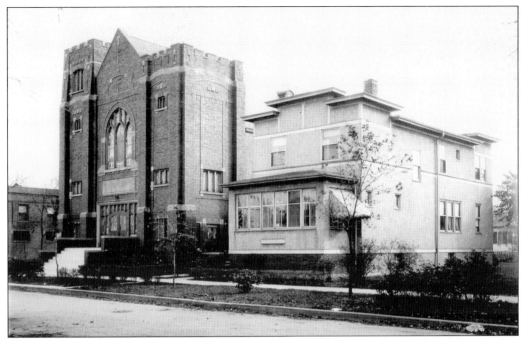

This view is of Nebo Swedish Evangelical Lutheran Church with a view of the parsonage that was built on the site of the first church. The parsonage has since been razed and is now an empty lot. (Courtesy of the Portage Park Center for the Arts.)

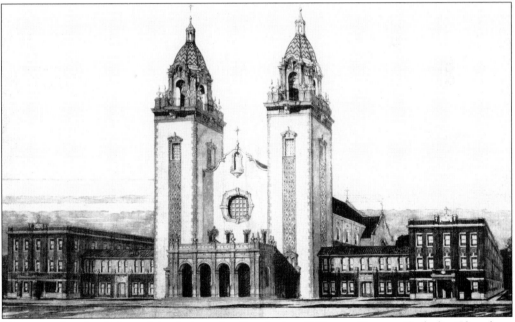

This is a sketch of the original plans for Our Lady of Victory Roman Catholic Church at 5212 West Agatite Avenue. A modified Spanish Renaissance design, the left tower was never built in a bid to cut costs. The parish's original committee consisted of two Poles, two Germans, and two Irishmen to sidestep some of the controversies over ethnicity that had developed in other Chicagoland parishes. (Courtesy of Our Lady of Victory Roman Catholic Church.)

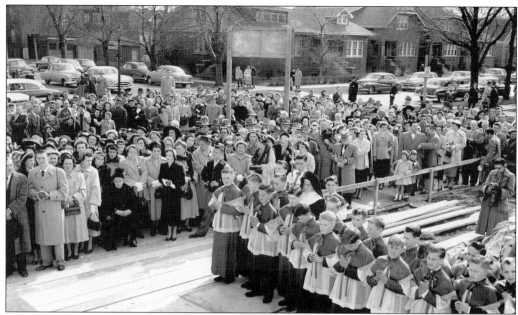

Here is a photograph taken from the blessing of the cornerstone for St. Ladislaus Roman Catholic Church in 1953. Originally a mission of historic St. Wenceslaus Roman Catholic Church in Avondale, the church was founded as a Polish parish in 1914 and was the center of one of Portage Park's first "Polish patches," Wladyslawowo, or "Ladislaus's village" in Polish. (Courtesy of St. Ladislaus Roman Catholic Church.)

This elaborate detail is from the facade at St. Ladislaus Roman Catholic Church. Located at 5345 North Roscoe Avenue, the current structure was completed in 1955 according to a design by Leo Strelka, who also designed the churches of St. Bronislava Providence of God on the city's south side. The first church was a shack donated by developer Edmund Szajkowski to lure in Poles from Polish Downtown.

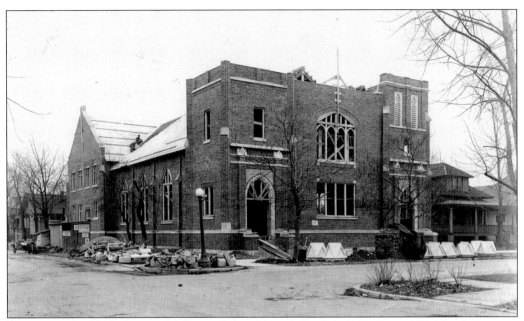

Here is a picture of the construction of Our Savior's English Church at 4159 North Laramie Avenue. The church was organized by the United Norwegian Lutheran Church in 1909. In 1998, it consolidated with seven other Lutheran churches to form United in Faith Lutheran Church, located in Chicago's Dunning neighborhood right next door to the Jolly Inn. (Courtesy of the Evangelical Lutheran Church in America archives.)

And here is a view of Our Savior's English Church once completed. A few blocks from Our Lady of Victory Church, the brick Gothic Revival structure on Laramie and Berteau Avenues is used today by Living Witness Apostolic Faith Temple, a Pentecostal congregation. (Courtesy of the Evangelical Lutheran Church in America archives.)

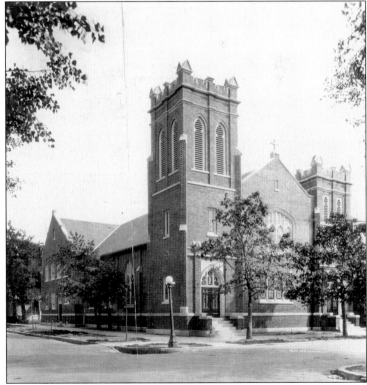

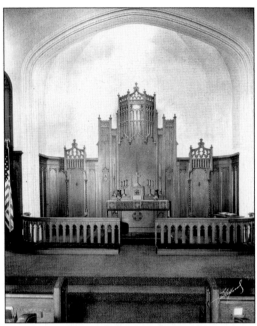

As seen in this view of the interior at Our Savior's English Church, the reredos, altar rail, and other interior decor continued the Gothic Revival stylistic theme of the building's exterior. (Courtesy of the Evangelical Lutheran Church in America archives.)

Nestled between two-flats and bungalows is a view of St. John of Rila the Wonderworker Bulgarian Orthodox Church at Cullom Avenue and Mason Avenue. The structure was built in 1928 as Peace Lutheran Church. Like Our Savior's, it too consolidated into United in Faith Lutheran Church in 1998. The church's interior has been adapted to conform to Eastern Orthodox liturgical requirements, and a magnificent hand-carved iconostasis has been installed depicting saints traditionally venerated in Bulgaria. (Courtesy of the Evangelical Lutheran Church in America archives.)

This is the original structure used by members of Peace Lutheran Church for worship. Later used as a parish house by the congregation, it still serves this function today for members of St. John of Rila the Wonderworker. As one of only two Bulgarian Orthodox churches in Chicago, it serves as a vital cultural center for this community on Chicago's northwest side. (Courtesy of the Evangelical Lutheran Church in America archives.)

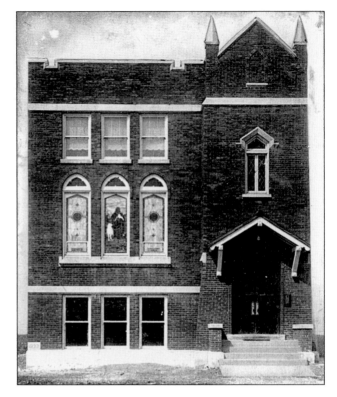

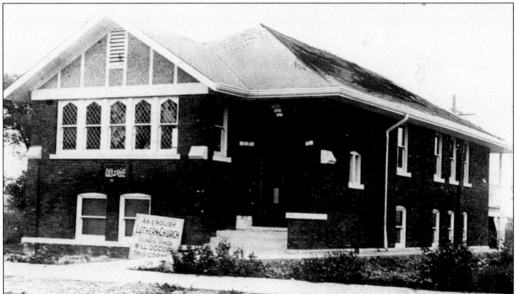

Dozens of bungalow churches dot Chicago's "Bungalow Belt." Here is a picture of the former St. Andrew's Lutheran Church located on Linder Avenue and Addison Street during the final stages of its construction in 1924. A larger structure was later added in 1955. Since St. Andrew's merged with other area Lutheran congregations to form United in Faith Lutheran Church, the church has been occupied by Liberty Christian Center. (Courtesy of the Evangelical Lutheran Church in America archives.)

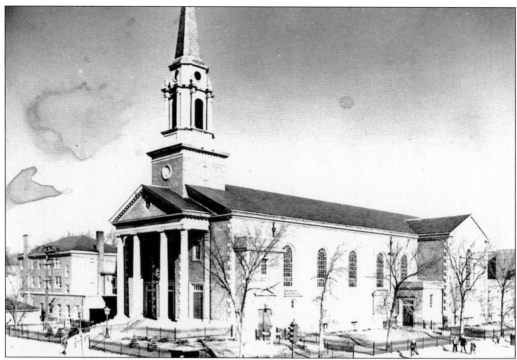

Located at Addison and Lavergne Avenues, St. Bartholomew Roman Catholic Church was designed by Gerald A. Barry in an American Colonial style as a conscious symbol of Cardinal George Mundelein's attempt to Americanize Catholicism, which was then associated with newly arrived immigrants. Choosing this most American of architectural idioms was a statement that Catholicism was compatible with American ideals and values. (Courtesy of St. Bartholomew Roman Catholic Church.)

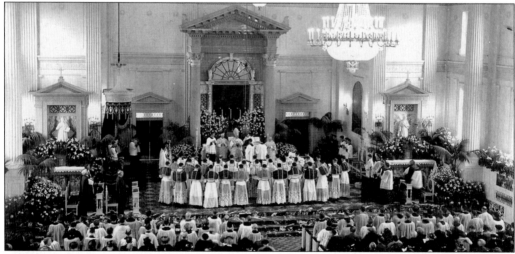

Here is a view of the interior during the church's dedication in 1938. A close look reveals substantial differences between the church then and how it appears today. The magnificent chandeliers are gone, as are both the main and side altars, having been replaced by simpler, less ornate structures, reflecting a general trend in Catholic churches after the end of the Second Vatican Council. (Courtesy of St. Bartholomew Roman Catholic Church.)

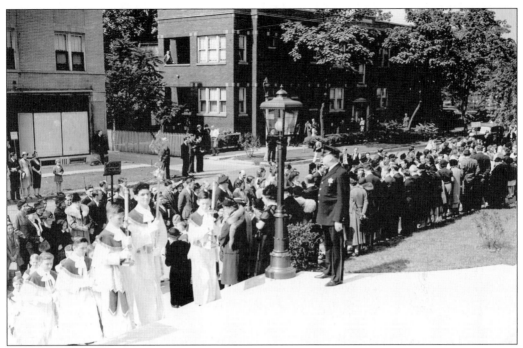

In another shot of the dedication ceremonies at St. Bartholomew Roman Catholic Church in 1938, altar boys lead a procession into the church for a mass celebrating its long-awaited completion. The care and attention that each of Portage Park's religious and ethnic communities put into creating and maintaining these structures was part of the story of planting their roots into the area. (Courtesy of St. Bartholomew Roman Catholic Church.)

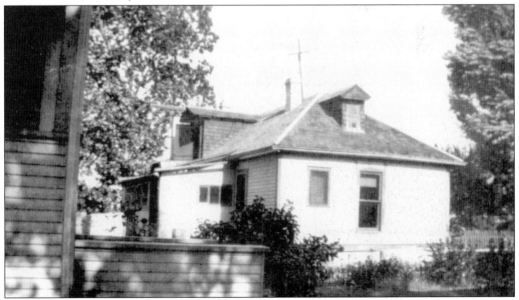

This humble home served as the original St. Robert Bellarmine Roman Catholic Church at 6028 West Slocum (currently Eastwood Avenue). This building was used until architect Joe McCarthy designed the combination church and school structure that still functions as St. Robert's Elementary School today. (Courtesy of St. Robert Bellarmine Roman Catholic Church.)

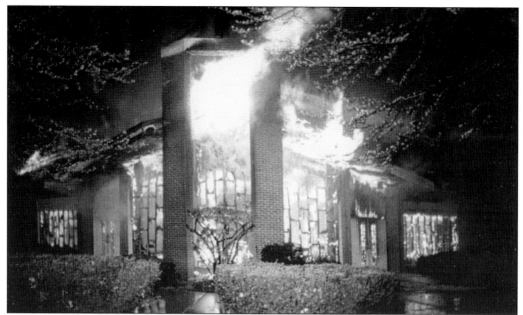

On Sunday May 9, 1988, Mother's Day, St. Robert Bellarmine Roman Catholic Church at 4646 North Austin Avenue burned to the ground. A passerby saw the church in flames at 4:00 a.m. and ran to the rectory to rouse auxiliary bishop Thaddeus Jakubowski. It was too late, however, to stop the fire's spread, and the building soon collapsed with little left to salvage. The church was rebuilt in 1989. (Courtesy of St. Robert Bellarmine Roman Catholic Church.)

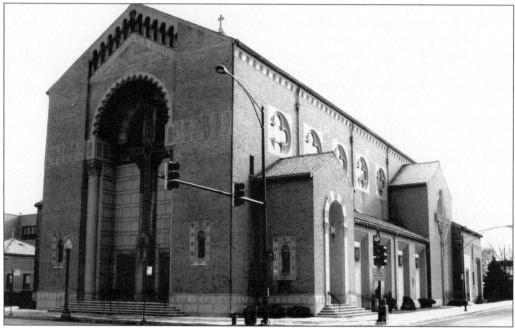

Along with St. Wenceslaus Roman Catholic Church in Avondale, St. Pascal Roman Catholic Church at 6143 West Irving Park Road is considered the best example of the fusion of art deco stylings with medieval European architecture in the city of Chicago. Locals once dubbed this gem built on land donated by developer Albert J. Schorsch "the Spanish shrine of silent art."

Five

BECOMING AMERICAN

Between the Civil War and World War I, Chicago's population grew a remarkable 2,450 percent, its population surging from slightly more than 100,000 in 1860 to over 2.5 million by 1920. Most of this growth was due to the massive deluge of immigrants from Europe to supply labor for the industries located in the "city of big shoulders." After these new arrivals left home to arduously travel halfway across the world, ethnic enclaves such as Polish downtown, Little Italy, and Pilsen helped them adjust to their new surroundings. Located close to the city center, these enclaves were often located in industrial surroundings that were horrendously overpopulated thanks to the constant inflow of new immigrants. One researcher calculated that around 1900 the population density in the vicinity of Grand and Milwaukee Avenues was greater than even that of the legendary "black hole" of Calcutta where Mother Teresa lived and worked. Farmland and prairie on the fringes of the city were transformed into residential neighborhoods. Portage Park was one of the areas where immigrants and their children who had grown up in these ethnic enclaves came to take part in the timeless American dream. While Portage Park also developed mini ethnic enclaves as large groups of people from the old neighborhood banded together to buy empty lots and found a church to serve their community, it was a mosaic of many different groups where no one group clearly dominated over the entire area. These enclaves possessed an entirely different quality, dominated not by new arrivals but by immigrants who had already adjusted themselves to their new American environment, as well their children who now wanted to own a piece of land and home like any other American. While still keen to preserve their old cultural folkways and customs, they were now proud Americans as well. Through local institutions and activities such as school, work, and play, bridges and bonds formed across ethnic and religious lines through the common fabric of life in the neighborhood. Portage Park's rich cultural diversity links the community together.

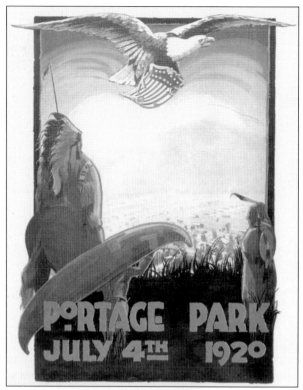

A flyer is from the Fourth of July celebration in 1920. Festivities such as this one helped to foster a joint sense of community across cultural and religious lines and created a deep attachment to the common space that dominated over the neighborhood at Portage Park. (Courtesy of the Sulzer Regional Library Historical Room, Chicago Public Library.)

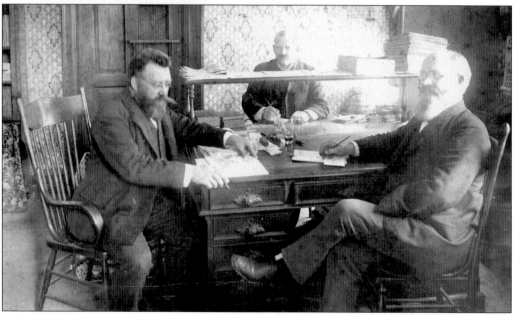

Churches served as magnets that first brought in residents from the city's congested ethnic enclaves and then became focal points for community life as they helped each group through its transformation from being immigrants to American citizens. Here is a picture of Ed Edstrom and other founding members of the Nebo Swedish Evangelical Lutheran Church. (Courtesy of the Portage Park Center for the Arts.)

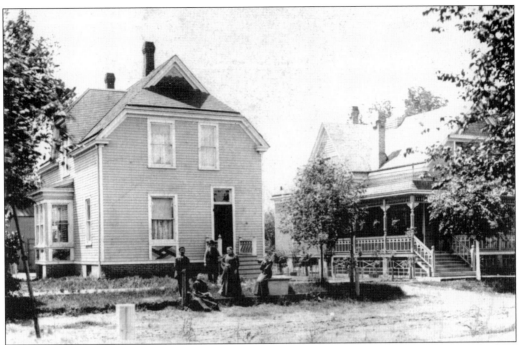

The desire for the country life brought many to the area. The serene, simple life offered an attractive alternative to the hustle and bustle of city living. Here on Leland Avenue near Milwaukee Avenue, the homes had large lots, abundant greenery, and unpaved streets. (Courtesy of the Jefferson Park Historical Society.)

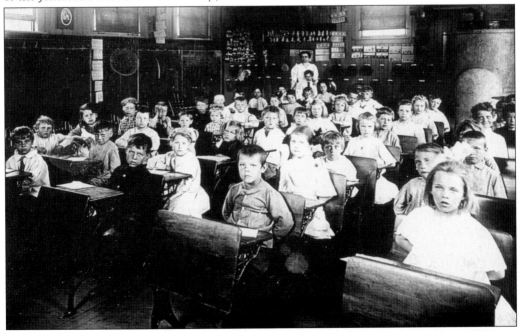

Here is a picture of a class in the orphanage that was set up in the former building of Martin Luther College. The institution was run with support from Nebo Swedish Evangelical Lutheran Church. (Courtesy of the Portage Park Center for the Arts.)

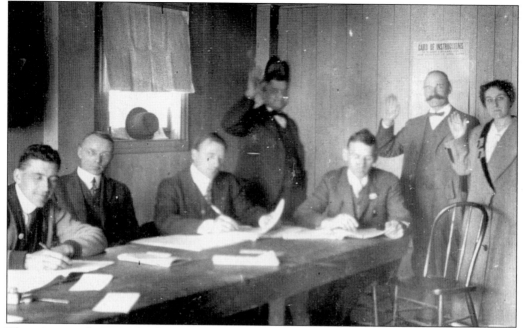

There is no right more fundamental as an American citizen than the right to vote. Here is a shot of Nebo Swedish Evangelical Lutheran Church serving as a polling place for area voters, a function that many Portage Park churches carry to this day. (Courtesy of the Portage Park Center for the Arts.)

In the Old Portage Park area, blocks of American foursquares, gorgeous Victorians, prairie-style bungalows, and Queen Anne homes line the streets. Walking down these streets even today can show how it looked back then. At 4041 Lawler Avenue, this frame Victorian still stands restored to its original luster. (Courtesy of Loraine Geraci and Scott Truhlar.)

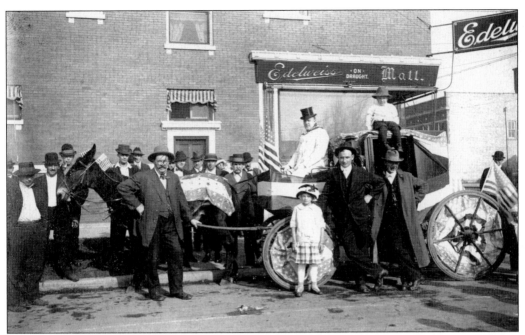

Here is a picture of Matthew Hermann in front of his saloon at Cicero Avenue and Dakin Street, taken about 1915. The shot illustrates the attempts made by German immigrants to show their American patriotism at a time when anti-German sentiment ran strong as World War I was being fought in Europe. (Courtesy of the Jefferson Park Historical Society.)

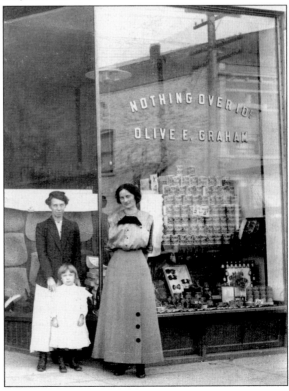

The family business is nothing new in Portage Park. Here is a view of Olive E. Graham with her sister Maud Peacock at the local dime store the Graham family ran in Portage Park. Located on 4774 North Milwaukee Avenue, the building still stands today. Local children would frequent the store to stock up on candy before visiting the nickelodeon at the nearby Casimir Theatre. The area was still largely empty to the extent that Olive was able to peek out the back of the store and see her home on Goodman Street. (Courtesy of the Jefferson Park Historical Society.)

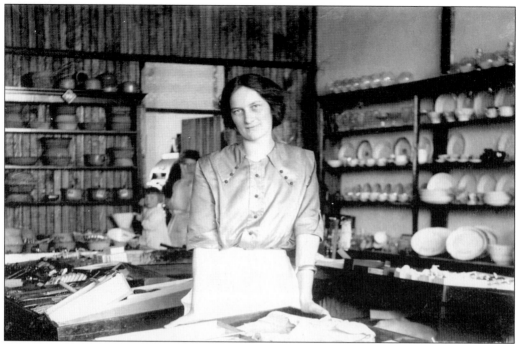

Olive E. Graham is standing inside the family dime store. The Grahams were longtime residents of neighboring Jefferson Park, with their roots in the area going back to the 1860s when Arthur Graham came here from Michigan. (Courtesy of the Jefferson Park Historical Society.)

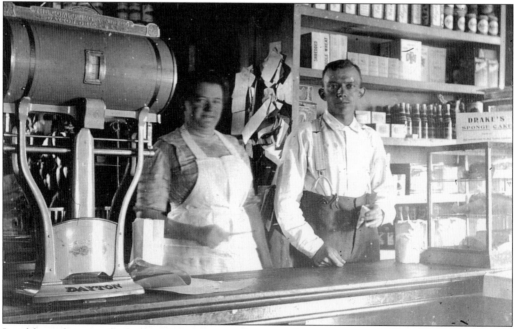

Just like today, people dream of opening up their own business instead of working for someone else. This shot shows the pride that came with the opportunity to open up one's own shop in Portage Park as people began settling the area. (Courtesy of the Portage Park Center for the Arts.)

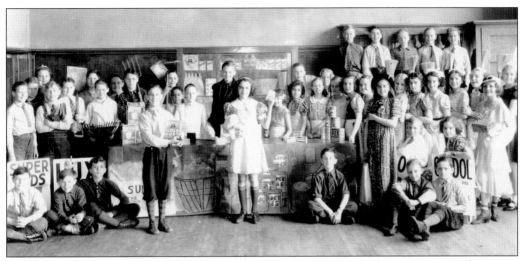

Here is a photograph of the first graduating class of Portage Park Elementary School in 1917. Reformers of the Progressive movement such as Jane Addams and Ellen Gates Starr saw the potential in these institutions to function as social centers integrating Chicago's diverse population. (Courtesy of Portage Park Elementary School.)

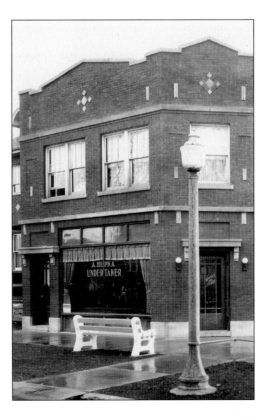

Adolf Hupka's funeral home was located at 5259 West Roscoe Avenue. Here was the core of Wladyslawowo, Portage Park's first "Polish patch," where Poles settled from long-established ethnic enclaves. Polish businesses, a church, and even a park named after the Polish composer Frédéric François Chopin were all within a couple blocks' radius. Interestingly enough, for a time, Hupka's Funeral doubled as the residence for the pastor of St. Ladislaus. (Courtesy of Reszke Funeral Home.)

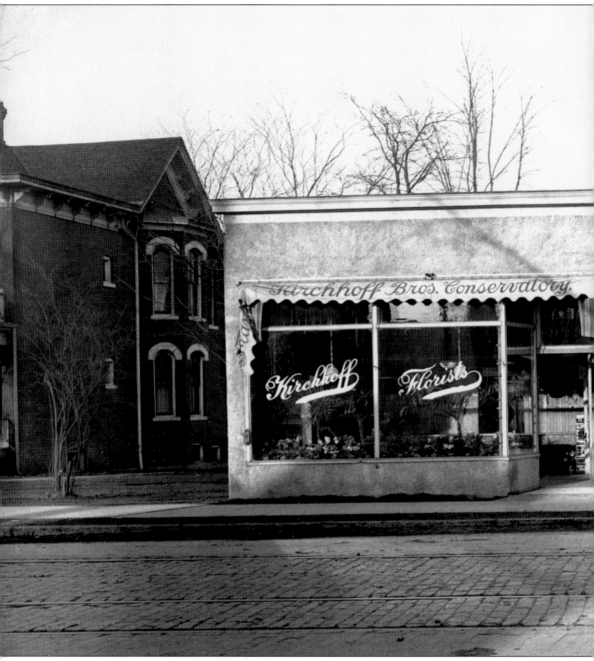

Here is a picture of the Kirchhoff Brothers Conservatory at 4711 North Milwaukee Avenue taken by John Groenier around 1915. Businesses integrated immigrants into the wider community as customers and clients of all different backgrounds shopped for goods and services they needed

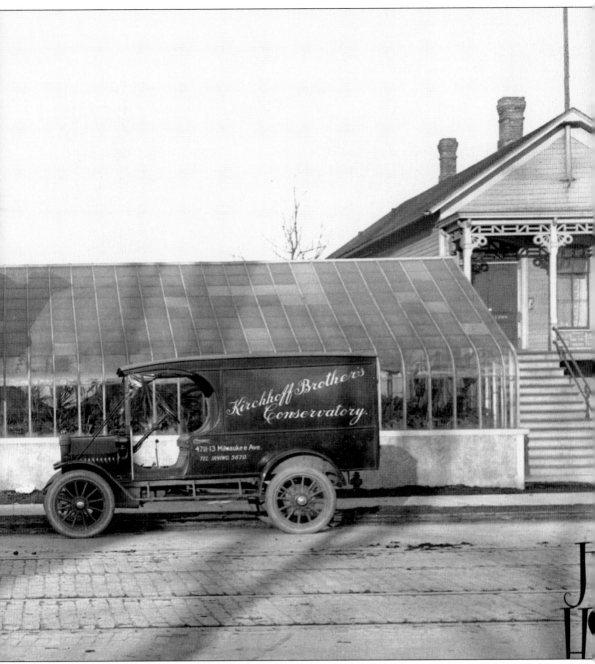

for the household. Run by Fred and Richard Kirchhoff, this local flower shop at Wilson Park's doorstep served residents of Portage Park, as well as nearby Mayfair and Jefferson Park. (Courtesy of the Jefferson Park Historical Society.)

Mario Novelli ran his barbershop at 5350 West Irving Park Road for almost half a century between 1949 and 2000, keeping the gentlemen of Portage Park looking clean shaven and dapper. His son Mario still keeps the family trade alive at his own shop in River Grove on Thatcher Avenue and Grand Avenue where figures of the Blues Brothers kindly greet clients at the door. (Courtesy of Mario Novelli.)

In a scene from days gone by, here is a shot of a local Scout troop paying a visit to Hagen's Fish Market. A reminder of the time when butcher shops and mom-and-pop delicatessens lined neighborhood streets, the store is the only fish store left in the Chicagoland area to operate a natural hardwood smokehouse. (Courtesy of Hagen's Fish Market.)

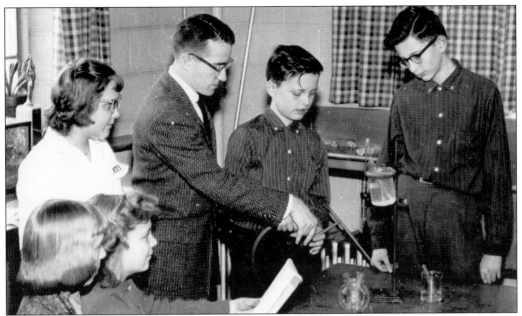

Here are students at St. John's Lutheran Elementary School. School helped integrate children who made up the diverse ethnic fabric of Portage Park. In addition to education, schools served an important role in Portage Park's early development by helping the children of immigrant parents learn the ways and customs of American society. (Courtesy of St. John's Lutheran Church.)

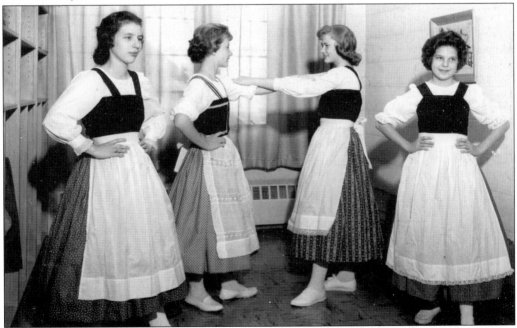

Young girls from St. John's Lutheran Elementary School display traditional folk dress while preparing for a showcase performance of German folk dance and song. Seen here once again is the same motif where Old World ethnic customs were still cultivated as a living link with their heritage by all the different peoples who settled the Portage Park area. (Courtesy of St. John's Lutheran Church.)

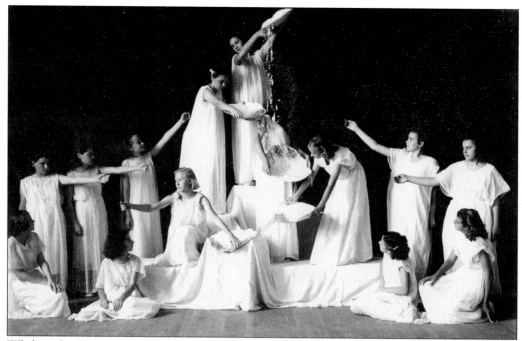

While today Prussing is strictly an elementary school, for a time it also housed a high school. This is an undated photograph from a performance staged by high school students at Prussing. (Courtesy of Ernst Prussing Elementary School.)

Young schoolchildren are learning to read and write. The language skills many of these children acquired here were priceless since English was often not the primary language of the home as many of the parents were immigrants from Europe. Local historian Allan Firak recounts that growing up in the area "everyone spoke English with an accent." (Courtesy of Ernst Prussing Elementary School.)

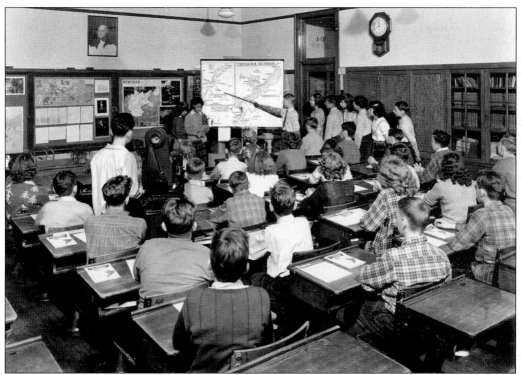

Here is a shot from Ernst Prussing Elementary School toward the end of World War II with a class presentation on Allied progress against the Japanese in the Pacific. (Courtesy of Ernst Prussing Elementary School.)

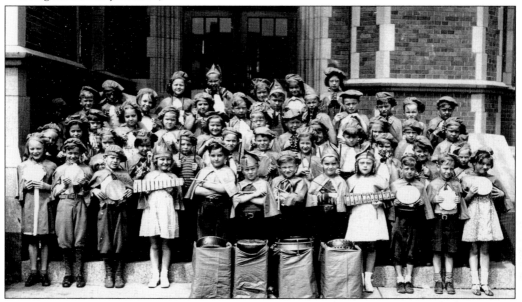

Teaching children music has always been a great way to help children develop skills and talents necessary for personal growth and social interaction. This wonderful shot of schoolkids in front of Ernst Prussing Elementary School shows how schools also helped to bring Portage Park's diverse community together. (Courtesy of Ernst Prussing Elementary School.)

Children from the orphanage pose on the front steps of Nebo Swedish Evangelical Lutheran Church. Today the building that formerly housed the church is still full of the rough-and-tumble of children as the Portage Park Center for the Arts, with its wide array of youth activities ranging from Saturday school in the Czech language to Scout meetings and art classes for kids. (Courtesy of the Portage Park Center for the Arts.)

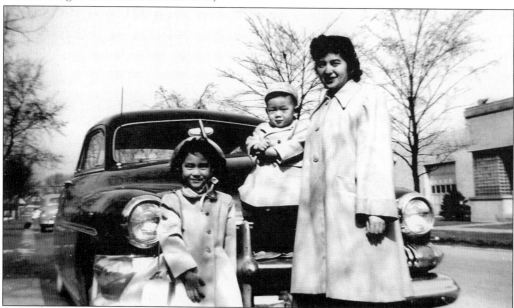

Portage Park has long been a place for people looking for a fresh start, such as the Kawamoto family. Coming to Chicago after spending World War II in a detention camp for Americans of Japanese descent, Sally Kawamoto and her children Jane and Wayne are in front of their home at 4716 North Laporte Avenue. (Courtesy of Jane Ohlin.)

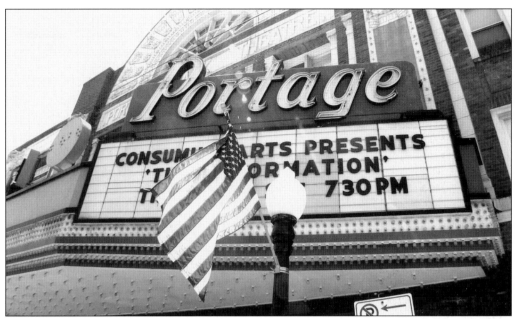

Here is a view of the Portage Theatre at 4050 North Milwaukee Avenue. Opening in 1920 as the Portage Park, the theater was designed by Mark D. Kalischer and Henry L. Newhouse for the Ascher Brother's circuit. Its name was shortened to the Portage in 1932, and after a period where the theater fell into disrepair, it has been magnificently renovated and reopened as a family-oriented performing arts venue.

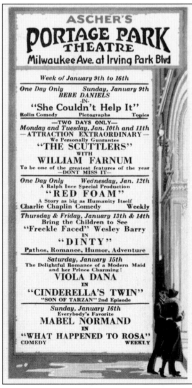

This old advertisement is for shows at the Portage Theatre. The theater was the first built in Portage Park specifically for film. In the era before television, going to the movies was the top of the line for leisure and entertainment in the neighborhood. Movie palaces like the Portage, the Patio, or the Belpark were simply the place to be.

This is a picture of the John V. May Funeral Home from the 1930s. May's Funeral Home was the final stop for many area loved ones before they were off to their final resting place at Union Ridge, Roseland, or St. Adalbert's Cemeteries. This lovely building, demolished in December 2005, is shown here with Chester's drugstore still occupying the left storefront before the funeral home occupied the whole building. (Courtesy of the Jefferson Park Historical Society.)

John V. May is sitting at his desk inside the funeral home. As local historian Frank Suerth notes, May was one of the first undertakers to offer an alternative place for the wake outside private homes. The wood beams that adorned the funeral home's interior were purportedly originally shipped from the Black Forest in Germany to be used in Chicago's Century of Progress Fair along the lakefront in 1934. (Courtesy of the Jefferson Park Historical Society.)

Here is a wedding photograph from St. Bartholomew Roman Catholic Church. Neighborhood churches helped to mark out important milestones within residents' personal lives and provided an occasion for people of different creeds to personally view the religious rituals of their friends and neighbors. (Courtesy of St. Bartholomew Roman Catholic Church.)

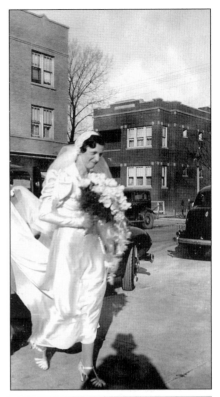

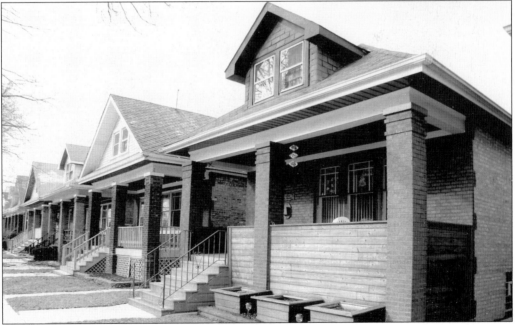

This is a view of the Schorsch Irving Park Gardens Historic District. Designed by two architects hired by developer Albert J. Schorsch, these bungalows are part of a residential complex listed on the National Register of Historic Places. The district's borders are Melvina Avenue to the west, Grace Street to the north, Austin Avenue to the east, and Patterson Avenue to the south.

Portage Park is home to one of only two Bulgarian Orthodox churches in all of Chicagoland, St. John of Rila the Wonderworker. Seen here is a picture of a visit to St. John of Rila by a member of the Bulgarian royal family, Princess Marie Louise of Bulgaria, the older sister of the current tsar of Bulgaria, Simeon II. (Courtesy of St. John of Rila Church.)

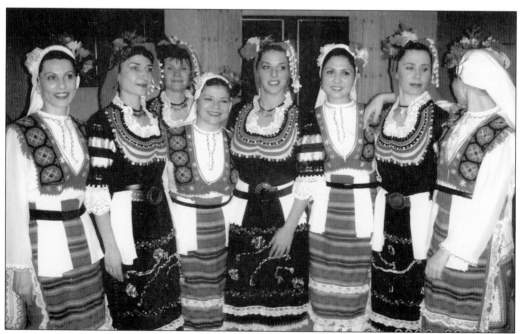

Here is a photograph of a Bulgarian folk troupe from St. John of Rila the Wonderworker Bulgarian Orthodox Church. Preserving their Slavic heritage, a modern continuation of the same story is seen as new ethnic groups come into the area and follow the same pattern set out by earlier residents who moved to Portage Park. (Courtesy of St. John of Rila Church.)

Six

THE PARKS OF PORTAGE PARK

It was the park in Portage Park that created the neighborhood, cobbling it together from the extensions of older surrounding communities in what had been Jefferson Township. Giving the neighborhood its center, the park served as the point of pride for locals where they could relax and play in this green oasis among the hustle and bustle of Chicago. Yet although it is the neighborhood's largest and most well-known park, there are four others serving the area: Chopin Park on Long Avenue, Dunham Park on Melvina Avenue, Wilson Park on Milwaukee Avenue, and Merrimac Park along Irving Park Road. The city's motto is the Latin phrase *Urbs in hortus*, which translates into English as the "city in a garden," a phrase that the city today stridently aspires to live up to. In recent years, there has been a dedicated campaign to beautify these shared spaces all over the city, and it has also helped revitalize Portage Park. Recently there has even been talk of installing bronze monuments at Portage Park commemorating the old portage along Irving Park Road as well as at Chopin Park in honor of the famous pianist the park is named after, but only time will tell if anything comes of these plans.

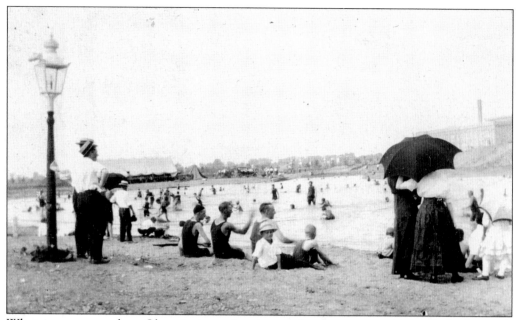

What is now a modern Olympic-size swimming pool was once a gathering hole for quick relief from Chicago's notoriously hot, muggy summers. This photograph is from when the sand-bottomed "lagoon," as locals quickly dubbed it, first opened in July 1916. The faint hills seen throughout the park landscape are the remnant of piles of sand left over from the lagoon's excavation. (Courtesy of the Portage Park Center for the Arts.)

A day at the park was no casual affair and required putting on one's Sunday best. Intended as a "breathing hole" amid the concrete jungle, Portage Park definitely fit the bill. The largest park on Chicago's far northwest side, it was here that people from all walks of life and ethnicities came to appreciate the greenery and, incidentally, got to know their neighbors. (Courtesy of the Portage Park Center for the Arts.)

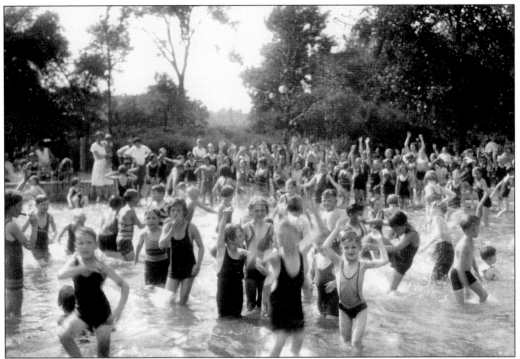

The sand-bottomed lagoon shown here was later replaced by a concrete pool in the 1930s by the Works Progress Administration (WPA) in an attempt to stem the spread of polio. The WPA was responsible for building the stonework fountains and gateways that people most typically associate with the park itself. (Courtesy of the Chicago Park District.)

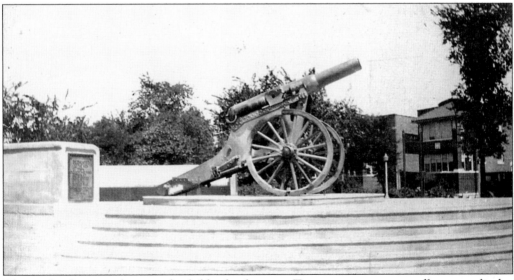

The spoils of one war became the fodder for the next. Two cannons were proudly put on display in Portage Park after World War I's end for all to see and respect. Ironically enough, they would eventually be melted down during the war effort for World War II to help alleviate the shortage of metals. (Courtesy of John Sowizrol.)

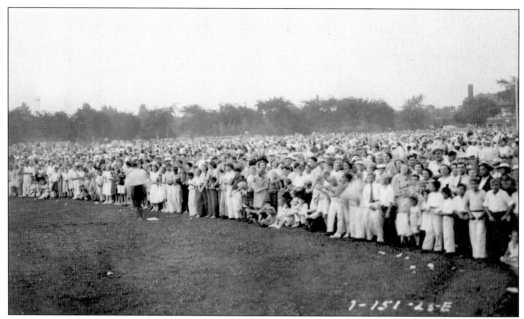

Portage Park's Fourth of July celebrations were widely known for their extravagant fireworks display, bringing in crowds of up to 40,000 people to the 40-acre park, as can be seen in this 1923 photograph. This annual Fourth of July tradition ended after an unfortunate accident one year where an audience member's flicked cigarette ignited a cache of explosives and left a number of crowd members seriously injured. (Courtesy of the Chicago Park District.)

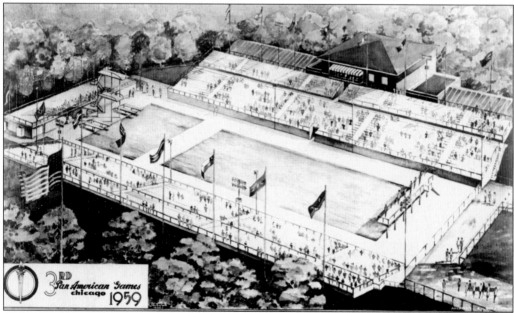

Above is a rendering showing plans for the Olympic-size pool, built in anticipation for the third Pan American Games, which replaced the concrete pool installed during the Great Depression. The games, the first held at a location outside Latin America, were held for 12 days between August 27 and September 7, 1959, with opening ceremonies held at Soldier Field. (Courtesy of the Chicago Park District.)

94

Mayor Richard J. Daley, true to his reputation as "Daley the Builder," is shown here pouring cement during the first phase of the pool's construction. The Pan American Games were originally slated to be held in Cleveland; however, the decision by Congress to cut $5 million of federal funding from the games forced the city to withdraw its bid and left Chicago next in line. (Courtesy of the Chicago Park District.)

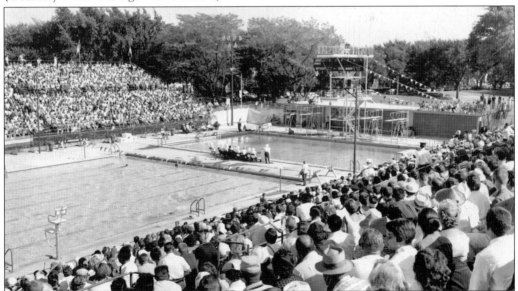

With Chicago's northwest side usually overlooked because of its blue-collar stigma, hosting the swimming portion of the Pan American Games left Portage Park residents with a refreshed sense of pride as world-class athletes journeyed here to compete on their doorstep. The legacy of the games would endure in the form of the finest public swimming facility in the entire city of Chicago. (Courtesy of the Chicago Park District.)

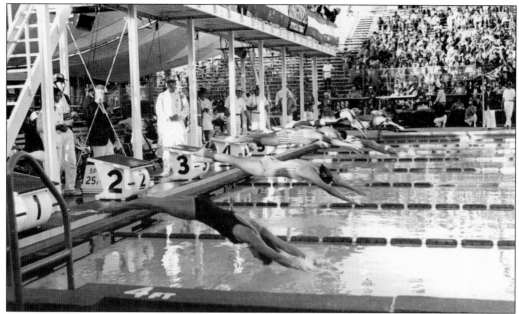

Organizing the Pan American Games was no small feat. Intense organization of the event left no stone unturned and polished it all off with the competitive swimming trials that brought extensive crowds. American athletes certainly reaped the benefits of home field advantage, winning a total of 115 gold medals, close to three times the 41 gold medals that all other countries participating won put together. (Courtesy of the Chicago Park District.)

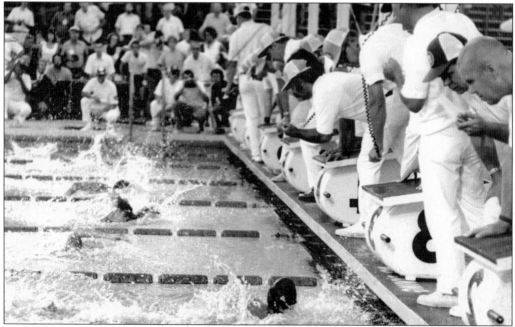

This action photograph of the swimming trials portrays the extreme passion that this event sets off for many. It was this kind of passion that gold medalist Mark Spitz would show in 1972 as he set new world records during the U.S. Olympic swimming trials held at Portage Park. (Courtesy of the Chicago Park District.)

The seemingly unlimited number of activities that Portage Park offered for children and young adults was remarkable. Each activity had plenty of participants, and with the addition of the new pool arena came the perfect opportunity to offer anything and everything that could utilize this invaluable social asset. (Courtesy of the Chicago Park District.)

Here is a wonderful snapshot of the high jump at Portage Park. Historian Ellen Skerrett maintains that during the height of the Depression few urban or suburban parks could equal the wealth of activities held here at Portage. Games like this created a sense of community, bridging across ethnic and religious lines to foster a sense of a common American identity. (Courtesy of the Chicago Park District.)

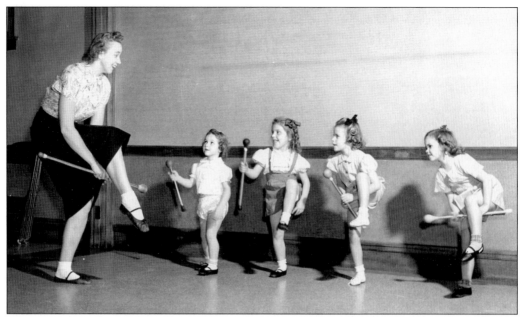

Classes such as baton for young girls made it possible for parents to offer their children rudimentary lessons in teamwork and group involvement. Access to all these activities and amenities was something that was highly valued by area parents, many of whom hailed from the old industrial areas by the Chicago River like Polish Downtown, Goose Island, or Pilsen. (Courtesy of the Chicago Park District.)

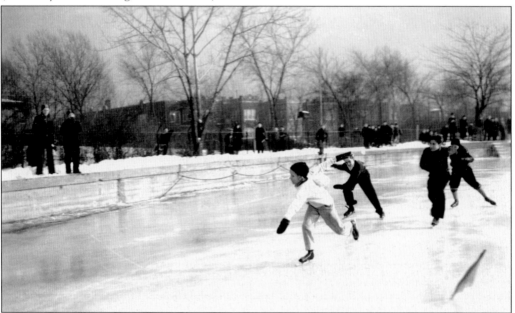

Every cloud has a silver lining; even Chicago's legendarily harsh winters are not enough to keep out the snowy high jinks. Every year, many of the parks in the Portage Park area would set up an ice-skating rink. Here is a picture of neighborhood children in Portage Park racing one another with a row of typical brick two-flats visible in the background. (Courtesy of the Chicago Park District.)

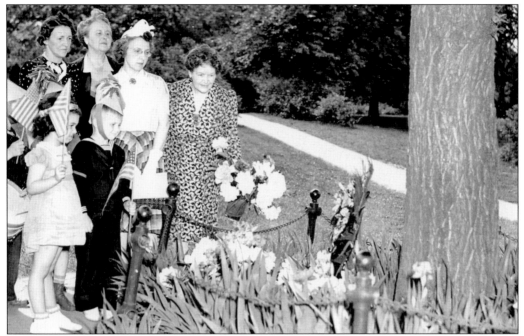

Here is a picture of children gathered at the memorial tree at Portage Park, paying tribute to all those who gave their lives in service to their country. To this day, students from nearby Portage Park Elementary School come here each spring to commemorate Memorial Day. (Courtesy of Portage Park Elementary School.)

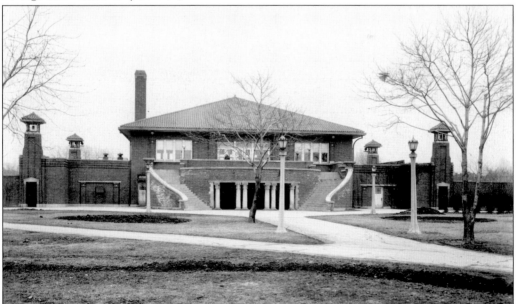

The natatorium in Portage Park was designed by Chicago native Clarence Hatzfeld. Both buildings represent a departure from the Tudor Revival style he generally favored, with these prairie-style structures constructed in a distinctive brown-green pressed brick. Both buildings are part of the Portage Park complex added onto the National Register of Historic Places in 1995. (Courtesy of the Chicago Park District.)

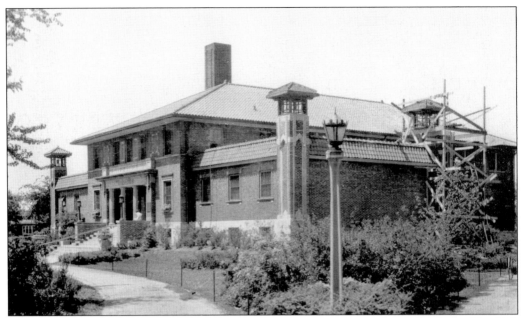

The Portage Park Gymnasium was built according to a design by architect Clarence Hatzfeld, who would later rise to prominence for his role in designing some of the more notable prairie- and craftsman-style homes in the landmark Villa District by historic St. Wenceslaus Roman Catholic Church. No other architect is responsible for the design of as many Chicago park field houses as Hatzfeld. (Courtesy of the Chicago Park District.)

This photograph shows a beautiful landscape of Portage Park in winter. Views such as this one highlight the charms of the park, which has served the neighborhood in its two roles as both a place for recreation and, as is plainly visible here, a place to take in inspiration. (Courtesy of the Evangelical Lutheran Church in America archives.)

This is a shot of the site that later became Wilson Park in 1914. Wilson Park is located off Milwaukee Avenue in the northeast corner of the Portage Park community area. According to residents, this area was once home to an old chicken farm. Slated to become a carbarn for the street railway company, local residents clamored to develop the nearly nine-acre site into a park. (Courtesy of Royna Johnson.)

Here is a picture from some of Wilson Avenue's first residents, the Johnson family. As seen here in the background, Wilson Park is nothing more than an open prairie in 1918. The elegant Georgian Revival field house along Milwaukee Avenue would not be built on the site for another decade and architecturally is nearly identical to the field houses at Shabbona and Chopin Parks. (Courtesy of Royna Johnson.)

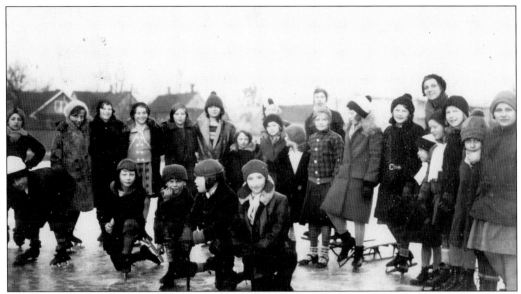

Children play in the snow in what is now Wilson Park. Ethnic and religious lines were bridged by the bonds formed through playful interaction with friends from all different backgrounds. The area was full of opportunities to explore Portage Park's rich cultural mosaic through everyday interactions as innocent as going over to a friend's house for some ethnic fare at supper. Golombki, anyone? (Courtesy of Royna Johnson.)

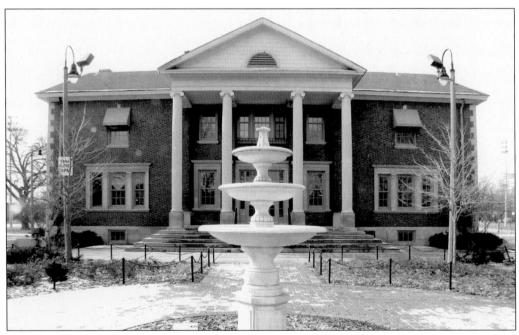

The Chopin Park field house at 3420 North Long Avenue is seen here. This historic Georgian Revival structure was designed by Albert Schwartz with a spacious assembly hall and stage. Named after the famed Polish-born composer Frédéric François Chopin, there has been recent talk of installing a monument honoring the park's patron.

Seven

GETTING AROUND

Portage Park's settlement was directly linked to the ability that residents had in traveling outside the area. As it became both easier and faster for people to trek through other parts of the city, the more it encouraged people to move into the area. This should come as no surprise since transportation has always been one of the key factors determining where humans have settled. Where people can go determines their abilities of what they can accomplish in a very immediate way. Yet the means by which people have gotten to where they need to go has changed over time, as new technology and innovations slowly but surely replaced the old. The following vintage photographs illustrate how people in Portage Park have gotten around the neighborhood in the past. These vintage shots of streetcars as well as the old "green limousine" buses are sure to stoke memories for older residents in the area and help to give others an idea of what life was like in the olden days.

Portage Park's development was no different than the rest of Chicago in that it was intimately tied to the railway. Two rail lines actually mark off Portage Park's eastern boundaries because of opposition faced from early settlers that forced railroad companies to reroute around the area.

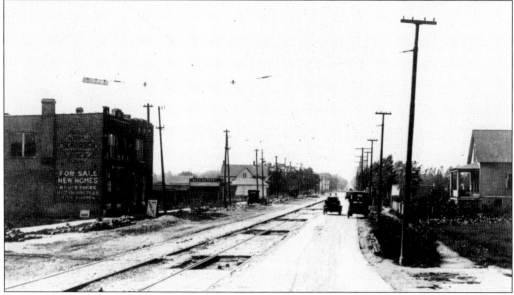

Here is a picture of Irving Park with a view of an advertisement for local developer Albert J. Schorsch on the side of the two-flat on the left. Born in the Austro-Hungarian Empire, Schorsch was responsible for building the bungalows of Schorsch Irving Gardens, a district on the National Register of Historic Places. (Courtesy of Ralph Frese.)

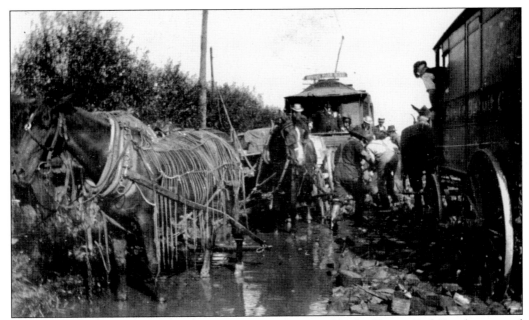

This picture shows a streetcar stuck in the mud on the 5800 block of Irving Park Road in around 1910. This stretch of Irving Park in the vicinity of today's Jesuit Millennium Center was unpaved with the exception of some creosote-soaked wooden blocks placed along the trolley tracks, a fact that the wagon pictured to the right is clearly taking advantage of. (Courtesy of the Portage Park Center for the Arts.)

A familiar scene in years gone by, streetcars would make their way along Irving Park until 1948 when they were replaced by trolleybuses that had been introduced along this route. This 1913 view shows a derailed trolley resting on the trackside embankment at the 5700 block of Irving Park Road. (Courtesy of the Portage Park Center for the Arts.)

This photograph shows a trolley in front of Kolze's Tavern. The business run by the Kolzes was immensely successful owing to its proximity to Chicago State Hospital as well as Mount Olive and Mount Mayriv Cemeteries. Visitors would stop in for a meal before the long journey back home, and coach drivers were assured a free meal if they brought paying customers to the inn with them. (Courtesy of Ralph Frese.)

Here is a view of the Irving Park Road streetcar in winter. Many area residents would ride it regularly on shopping excursions to Six Corners, which at the time was the largest retail area outside of the downtown Loop. (Courtesy of the Portage Park Center for the Arts.)

A view of wagon trails looking east from the intersection of Belmont and Central Avenues in 1904 shows what transportation in Portage Park looked like during its rustic heyday. (Courtesy of the Chicago Public Library, Special Collections and Preservation Division.)

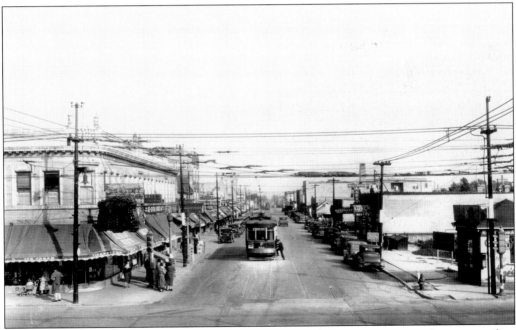

This is the same intersection 30 years later in 1934. Looking east, one sees the street railcar approaching a vista that is largely unchanged today. The Belmont-Central Business District, which straddles Portage Park and Belmont-Cragin, holds the largest concentration of Polish shops in Chicago today. (Courtesy of the Chicago Public Library, Special Collections and Preservation Division.)

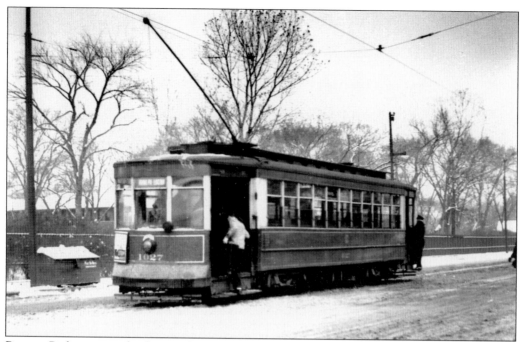

Portage Park owes much of its residential growth to the expansion of the streetcar lines through the area. They were affordable transportation for members of the working class as opposed to the more expensive railroads. (Courtesy of Ralph Frese.)

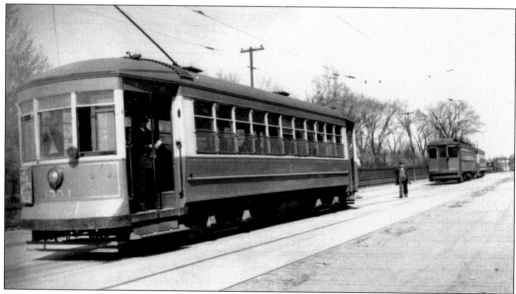

Here is a view of the trolley on Narragansett Avenue. Some residents recall local lore that during Prohibition Al Capone's men would drive down Narragansett at night on supply runs in an attempt to skirt the city since the street ran largely outside Chicago at the time. (Courtesy of Ralph Frese.)

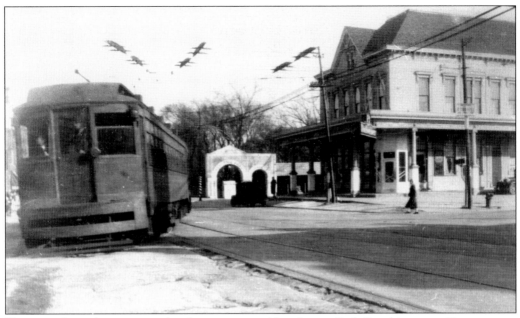

Here is a shot of a streetcar that has run aground at Irving Park Road just past Narragansett Avenue in front of Kolze's Grove. On weekends, the Irving Park and Narragansett streetcars would be full of revelers heading for festivities at the picnic grounds. (Courtesy of Ralph Frese.)

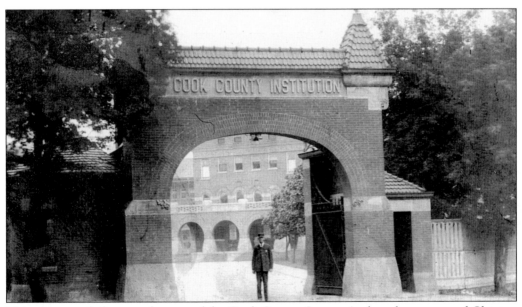

This photograph features the gate of the Cook County Insane Asylum, later renamed Chicago State Hospital. The development of the Austin-Irving area, as well as neighboring Dunning, was highly dependent on Chicago State Hospital as a source of employment. Through the 1950s, a siren would sound to let nearby residents know when an inmate had escaped. (Courtesy of the Portage Park Center for the Arts.)

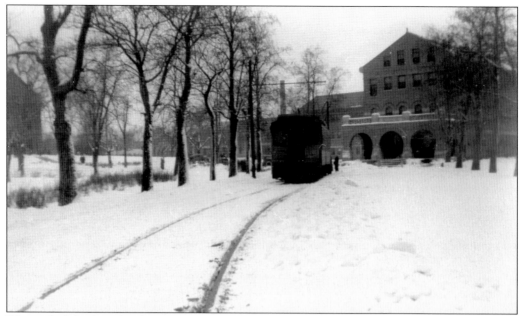

The end of the line for the "Crazy Train" at first referred to a spur of the Chicago, Milwaukee and St. Paul line that ran destined for Chicago State Hospital along Neenah Avenue through Mount Olive Cemetery until the line made its last run in the early 1930s. The line's tracks are still visible when passing the Brickyard Shopping Center along Diversey Avenue. (Courtesy of Ralph Frese.)

Here is a view of the streetcar "Crazy Train" riding through the brush at Chicago State Hospital. The Chicago, Milwaukee and St. Paul line spur was replaced with this streetcar running directly between Cook County Hospital on Chicago's West Side and Chicago State. After the car had finished transporting patients between Cook County Hospital and Chicago State, passersby would watch its menacing hulk make its way down Irving Park Road until it turned southeast on Milwaukee Avenue at Six Corners, where the car would go down California Avenue until it hit Chicago Avenue, then head west on Chicago to Kedzie Avenue, and from there go to its terminus at the Kedzie depot at Kedzie and Van Buren Street. (Courtesy of Ralph Frese.)

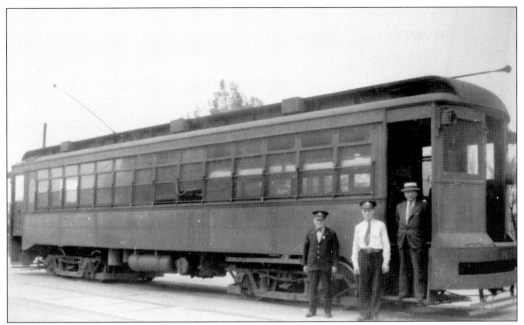

This is a shot of the infamous "Crazy Train" streetcar, or Cook County car No. 1. Area residents such as the Glowaczewski family recall it as "being painted an ugly dark green with oversized wheels," and liken its movements to "a Sturmorser tank along Irving Park Road." (Courtesy of Ralph Frese.)

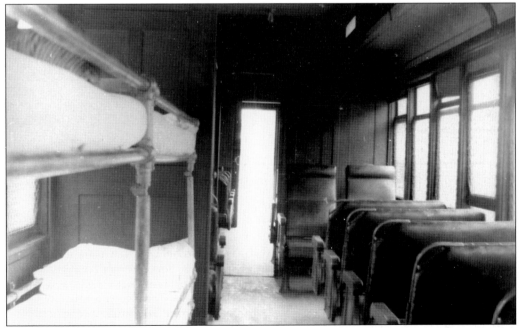

Here is the interior of the infamous "Crazy Train." This picture shows the windows and the leather seats as well as the beds used for strapping more troublesome passengers. The partition in the middle of the car was in place to separate the male and female patients, with the female patients seated closest to the motorman. (Courtesy of Ralph Frese.)

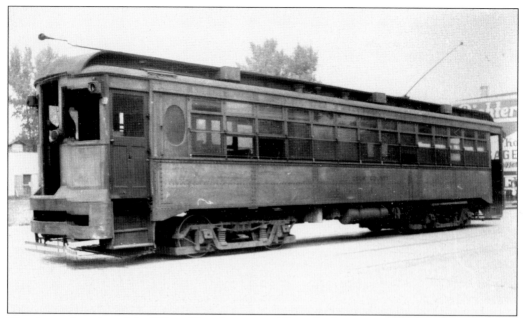

Here is another view of the "Crazy Train" streetcar. The vehicle was run by two Irishmen, Daniel O'Brien and Patrick Gibbons, from the trolley's first trip in 1918 through its final journey in May 1939. The car was scrapped by the end of that year. (Courtesy of Ralph Frese.)

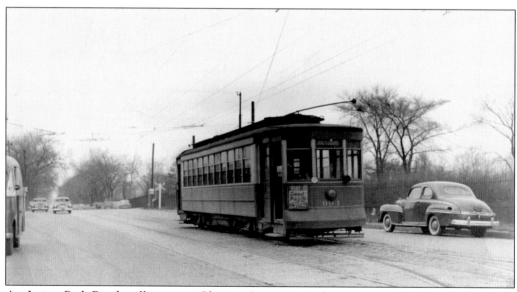

An Irving Park Road trolley passes Chicago State Hospital at Neenah Avenue traveling east. Parents would scare their misbehaving children that they would "send them to Dunning," an informal name for the institution after the community neighboring Portage Park to the west. (Courtesy of Ralph Frese.)

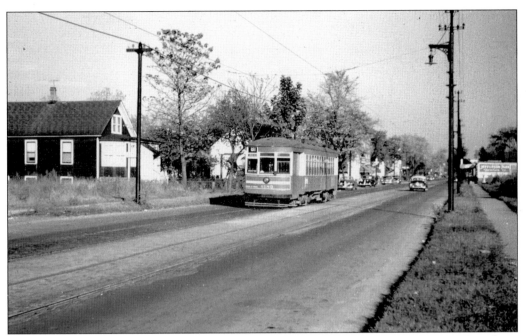

This view shows a streetcar going down Lawrence Avenue near Austin Avenue. Residents living along Portage Park's northern edge recount taking the Lawrence streetcar to see the movies at the majestic Gateway Theatre in neighboring Jefferson Park. (Courtesy of St. Robert Bellarmine Roman Catholic Church.)

This young girl is beaming with pride in front of the new family car. The automobile replaced the streetcar as the primary mode of transportation for the average Portage Park resident the same as it did across the rest of the United States. (Courtesy of John Sowizrol.)

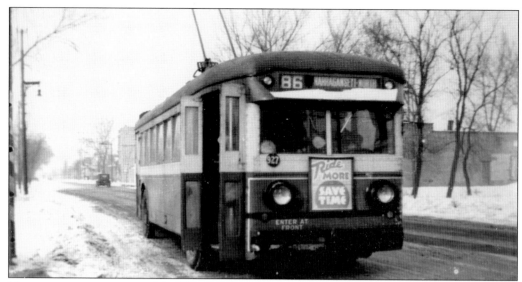

Here is a vintage picture of the Narragansett Avenue bus. The "green limousines," as Chicago Transit Authority buses were referred to by native Chicagoans, replaced the network of streetcars that ran throughout the span of the city. (Courtesy of Ralph Frese.)

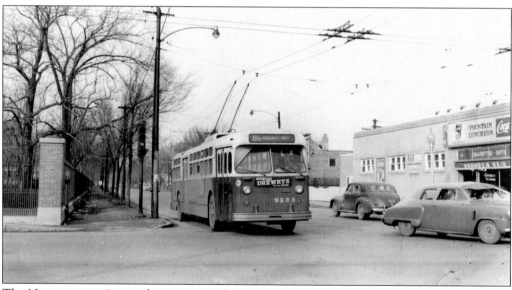

The Narragansett Avenue bus is passing by Mount Olive Cemetery. Both of these shots show trolleybuses, which were electrically powered through power lines hanging over the streets. These vehicles were later scrapped and replaced with gas-powered buses at a time when cheap gasoline made the move appear cost-effective. (Courtesy of Ralph Frese.)

Eight

A "NEIGHBORHOOD" NEIGHBORHOOD

Portage Park is, in a sense, like many other Chicago neighborhoods, another district of the city that is served by the same entities and services no differently than any other area within the city limits. Yet despite the lack of attention the area shares with the rest of Chicago's northwest side, it possesses a value many other urban areas lack: a true sense of community. In how many other areas of Chicago, or any other large American city for that matter, can one find the same kind of continuity across generations living in the same neighborhood? Most of the Portage Park residents who were kind enough to donate their pictures or their knowledge toward this book have themselves lived in the area all their lives, sometimes in the very same home that they or their parents built decades ago. The fact that so many people in Portage Park choose to put such deep roots in the area is without a doubt the most amazing discovery made in the process of putting together this book.

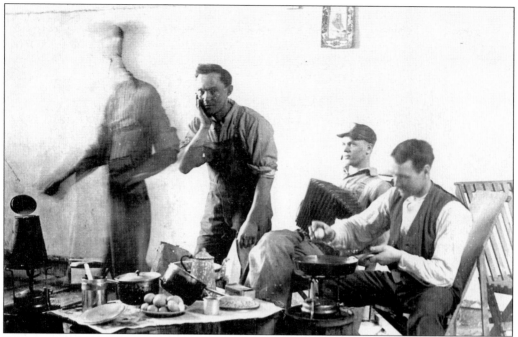

Taking a break from building homes in the Martin Luther College subdivision, residents and workmen make some time for lunch. Buying an empty lot and constructing a house of one's own was not uncommon in those days, and catalogs by firms such as Sears offered a variety of complete floor plans with most of the components for just such a task. (Courtesy of the Portage Park Center for the Arts.)

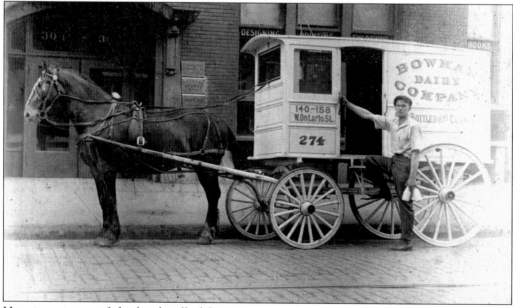

Here is a picture of the local milk deliveryman, or "Gus," as locals knew him. Considered a neighborhood fixture, he regularly delivered dairy goods from the Bowman Dairy to families in the vicinity of Lawrence and Austin Avenues, or Frogtown, as locals dubbed the area. (Courtesy of St. Robert Bellarmine Roman Catholic Church.)

When prosperity swept through the city, so did pride. At the time it was not uncommon for residents to take pictures in front of their prized new automobiles. With cars more of a luxury than a necessity, it was a good way to show off to their friends and relatives back home how well off they were. (Courtesy of the Portage Park Center for the Arts.)

This is a 1918 photograph from the meeting of the local Council of National Defense organized in response to the entry of the United States into World War I. Taken along what is now Berteau Avenue, Chicago followed the lead of the rest of the country, putting its heart into the war effort. (Courtesy of the Sulzer Regional Library Historical Room, Chicago Public Library.)

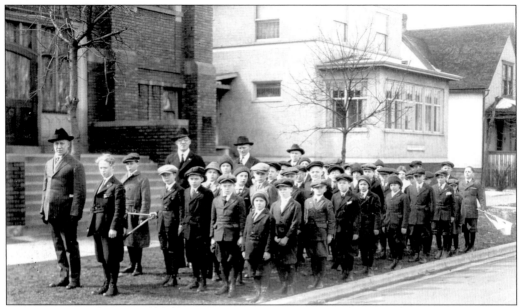

Children of the Nebo Swedish Evangelical Lutheran Church form a disciplined line in front of the church and neighboring parsonage in 1922. Historian Ellen Skerrett wrote in her essay on Portage Park in *The Chicago Bungalow* that churches were not only instrumental in attracting residents from the old ethnic enclaves, they were also responsible for "transforming the children of immigrants into citizens." (Courtesy of the Portage Park Center for the Arts.)

The flat roofs of Chicagoland's ubiquitous two-flats have a long-standing tradition of serving as the cozy setting for neighborly gatherings. Here two parishioners from St. Bartholomew's Roman Catholic Church enjoy some rest on a lazy Sunday. (Courtesy of St. Bartholomew Roman Catholic Church.)

Dr. Weiland, the 45th Ward alderman as well as the neighborhood dentist, resided and worked in this home now found on Montrose Avenue. Originally located on Sunnyside and Milwaukee Avenues, it was moved using horses to get away from the noise of the Sunnyside surface rail. Since then, it was moved another four times until it finally reached its present-day location. (Courtesy of Augustino and Catherine Napoli.)

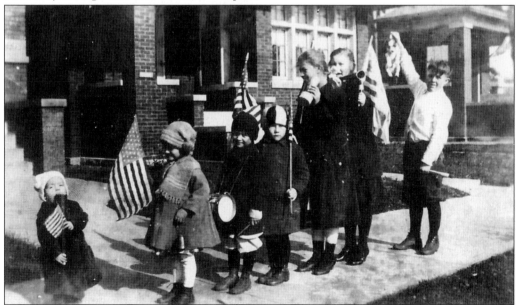

The end of hostilities at the close of World War I was greeted everywhere with glee and relief. Portage Park was no different, and the Wilson Avenue Peace Day parade was a community affair. This picture depicts a snapshot of the event, with kids wielding flags, noisemakers, and drums and celebrating on Wilson Avenue just west of Wilson Park. (Courtesy of Royna Johnson.)

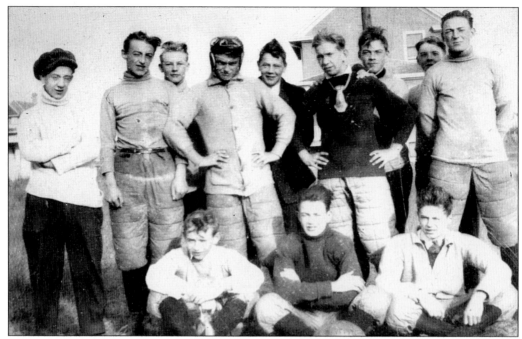

Here is a shot of neighborhood boys from Nebo Swedish Evangelical Lutheran Church getting ready to play football, emulating their favorite sports stars on home turf. These newly developed and still unfenced lots made for an ideal sports arena for locals to play on. (Courtesy of the Portage Park Center for the Arts.)

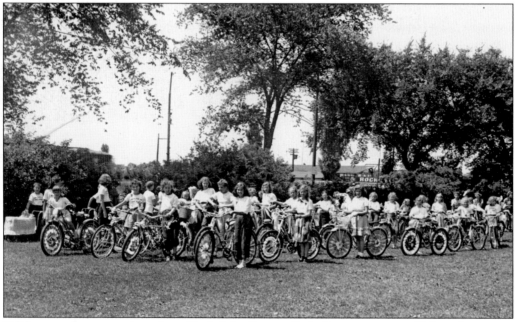

Of the countless recreations that afforded the Portage Park district, an annual bike-riding event took the neighborhood by surprise. The park's day camp would organize the children in the park with their bikes and constructively ride through the area creating a scene that many would stop to enjoy. (Courtesy of the Chicago Park District.)

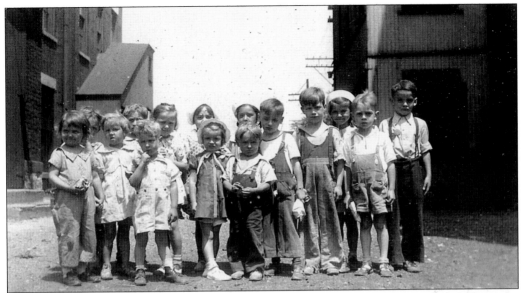

Children are seen here hanging around the neighborhood. Many residents reminisce about the days gone by growing up in Portage Park. A great example of this is in the 1991 reunion of a single block of Byron that brought together 46 former residents, some of whom traveled in from out of state to attend. Where else but in Portage Park would one find a reunion of old residents from a single city block? (Courtesy of St. Bartholomew Roman Catholic Church.)

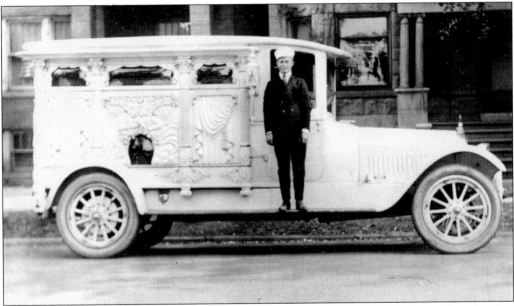

According to neighborhood lore, this was the "cursed hearse." The story goes that the first funeral this hearse serviced was for a boy who died of lung cancer. After a minor car accident that damaged the front end, the brother and father of the boy who died worked on the car. After both later suffered and died from lung cancer as well, the car was labeled as cursed and sat in storage for decades unused out of terror. (Courtesy of Reszke Funeral Home.)

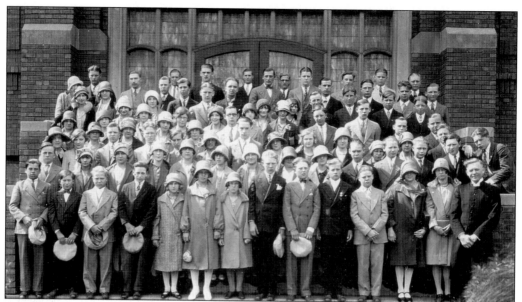

Young members of Nebo Swedish Evangelical Lutheran Church are seen in this photograph. While Nebo is gone today after having consolidated, the building still carries on a vital function as the Portage Park Center for the Arts. Hosting everything from yoga classes in both English and Polish, art lessons for children, Czech Saturday school, lectures by historians, and teachings by Tibetan monks, the center is a true community gem. (Courtesy of the Portage Park Center for the Arts.)

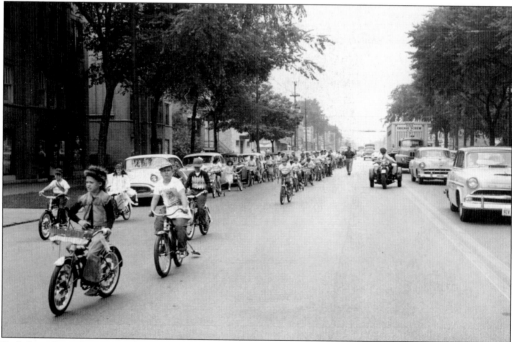

Pedaling down Irving Park Road, Portage Park Day Camp's bicycle parade drew everyone's gaping attention. How much more fun can there be for kids than to have adults make way for them while getting to shine in the spotlight? (Courtesy of the Chicago Park District.)

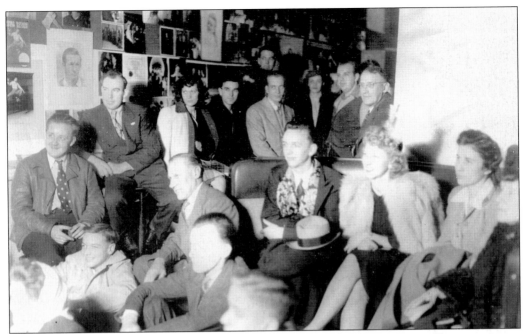

Then as now churches were places not only for worship but also for recreation. Here is a picture of young people at Nebo Swedish Evangelical Lutheran Church laying back and watching a performance in a room of the church basement. (Courtesy of the Portage Park Center for the Arts.)

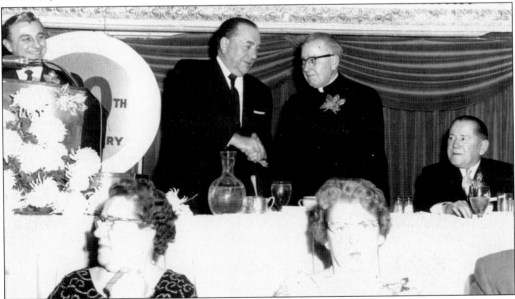

Here is a picture of Mayor Richard J. Daley with Msgr. Stanislaus Czapelski at a banquet celebrating the cleric's 50th anniversary of ordination to the priesthood. As the longtime pastor of St. Ladislaus Roman Catholic Church, Czapelski was a leading figure of Portage Park's Polonia, or Polish American community. Today Portage Park possesses the largest concentration of Polish Americans in the Chicago metropolitan area. (Courtesy of St. Ladislaus Roman Catholic Church.)

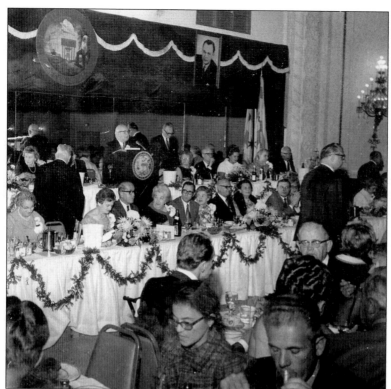

Here is a photograph from a fund-raiser for current mayor Richard M. Daley's campaign for state attorney at Golden Tiara Banquets, just north of Belmont Avenue on Cicero Avenue. Before becoming a banquet hall, it was one of Portage Park's premier movie palaces, the Belpark Theater. In addition to films, the Belpark once hosted live shows with visiting actors staying at the nearby Elinor Hotel. (Courtesy of the Andolino family.)

Here is a shot of current mayor Richard M. Daley at the formerly luxurious Belpark Theater. The largest theater built without a balcony in Chicago, it was run by Balaban and Katz until it closed in 1958. It was first converted into a Steinberg and Baum department store before it was used for banquets until finally becoming a bingo hall in the 1980s. (Courtesy of the Andolino family.)

Current mayor Richard M. Daley makes an appearance at Wilson Park on Milwaukee Avenue with current alderman of Chicago's 45th Ward Patrick Levar. All politics is local, and "da mayor" himself made an appearance to cut the ribbon for the new play area at Wilson Park. (Courtesy of the Chicago Park District.)

Here is a picture of Kurt Ohlin, the former owner of the ubiquitous K&K Tavern that was located in the Schuenemann building at 4423 Milwaukee Avenue, as a student at Portage Park Elementary School. Photographs like this were taken for memorial books that each student would put together for their parents, writing about the year they spent learning in school. (Courtesy of Jane Ohlin.)

A Guide to Portage Park

Sites on the National Register of Historic Places

Schorsch Irving Park Gardens Historic District
Portage Park

Other Historic Sites

The Portage Park area portage (which ran along what is today Irving Park Road between the Des Plaines and Chicago Rivers)
The former site of the Dickinson Tavern (now a strip mall at the 4000 block of North Milwaukee Avenue)
The former site of Jefferson Town Hall (now a branch of LaSalle Bank at 4747 West Irving Park Road)
The former site of Martin Luther College (now a parking lot for the Jesuit Millennium Center at 5800 West Irving Park Road)
The former site of Kolze's Grove (now Merrimac Park at 6343 West Irving Park Road)
The former Chicago 21 club at 6020 West Belmont Avenue (site of the first show performed by the Smashing Pumpkins)
Chris's Billiards at 4637 North Milwaukee Avenue (site where *The Color of Money* was filmed)
The site of the first store opened by the Polk Brothers in 1935 at 3334 North Central Avenue

Former Upscale Hotels

Name	Address	Years of Construction
Irving Park Hotel	4849 West Irving Park Road	1920s
Elinor Hotel	3216 North Cicero Avenue	1920s

Movie Palaces

Name	Architect	Address	Year
Portage Theatre	Mark D. Kalischer and Henry L. Newhouse	4050 North Milwaukee Avenue	1920
Belpark Theater	Edward P. Steinberg	3231 North Cicero Avenue	1927
Patio Theater	Rudolph G. Wolff	6008 West Irving Park Road	1927

Architecturally Notable School Buildings

Name	Architect	Address	Year
St. Robert Bellarmine Elementary	Joseph McCarthy	6036 West Eastwood Avenue	1931
Portage Park Elementary	Arthur Hussander	5320 West Berteau Avenue	1915
William Gray Elementary	Arthur Hussander	5228 West Warwick Avenue	1911
Ole A. Thorp Elementary	Arthur Hussander	6024 West Warwick Avenue	1918
Edwin G. Foreman High	John Christensen	3201 North Leclaire Avenue	1928
Washington D. Smyser Elementary	Paul Gerhardt	4301 North Melvina Avenue	1932
Chicago Academy	Paul Gerhardt	3400 North Austin Avenue	1934

Architecturally Notable Churches

Name	Architect	Address	Year
Our Lady of Victory	Meyer and Cook	5228 West Agatite Avenue	1954
North Side Gospel Center		3849 North Central Avenue	1930s
St. John's	Herbert A. Brand	4939 West Montrose Avenue	1930
Jesuit Millennium Center	Wojciech Madeyski	5835 West Irving Park Road	2001
St. Ladislaus	Leo Strelka	5345 West Roscoe Avenue	1955
Jefferson Park Congregational	Michaelson and Rognstad	4733 North London Avenue	1929
St. John of Rila the Wonderworker		5944 West Cullom Avenue	1928
St. Pascal	Raymond J. Gregori	3935 North Melvina Avenue	1930
Ratna Shri Sangha Chapel	Rinchen Dorjee Rinpoche	5337 West Cullom Avenue	2003
St. Bartholomew	Gerald A. Barry	3605 North Lavergne Avenue	1938

Architecturally Notable Commercial Buildings

Name	Architect	Address	Year
Dayan's	Edward P. Steinberg	5546 West Belmont Avenue	1929
Belmont-Central building	John G. Steinbach	5600 West Belmont Avenue	1928
People's Gas Irving Park store	George Grant Elmslie and Hermann Von Holst	4839 West Irving Park Road	1926
Bengson Building	Johan F. Knudson	3919 North Milwaukee Avenue	1916
Polish Army Veterans Association building	Axel V. Teisen	6001 West Irving Park Road	1928

Other Architecturally Notable Buildings

Name	Architect	Address	Year
Chopin Park Field House	Albert A. Schwartz	3420 North Long Avenue	1930s
Portage Park Field House/Natatorium	Clarence Hatzfeld	4051/4101 North Central Avenue	1922/1928
Polish American Association building		3834 North Cicero Avenue	1920s
St. Bartholomew rectory	Gerald A. Barry	4949 West Patterson Avenue	1940

Architecturally Notable Residences

Address	Architect	Year
5834 West Addison Street	Grotz Wagelin Company	1928
4968 West Berteau Avenue	Frederick Pischel	1912
5501 West Cullom Avenue	Slupkowski and Piontek	1926
4135 North Dickinson Avenue	A. A. John	1920s
4100 block of North Leamington Avenue	Various	
3705 North Lockwood Avenue	Anthony A. Tocha	1923
4021 North Lockwood Avenue	Charles F. Wheeler	1916
4058 North Melvina Avenue		1900s
4705 North Milwaukee Avenue	Otto Kaiser	1890s
4840 West Pensacola Avenue	Walter Burley Griffin	1910
5741 West Windsor Avenue	Ernest Braucher	1914

ACROSS AMERICA, PEOPLE ARE DISCOVERING SOMETHING WONDERFUL. *THEIR HERITAGE.*

Arcadia Publishing is the leading local history publisher in the United States. With more than 3,000 titles in print and hundreds of new titles released every year, Arcadia has extensive specialized experience chronicling the history of communities and celebrating America's hidden stories, bringing to life the people, places, and events from the past. To discover the history of other communities across the nation, please visit:

www.arcadiapublishing.com

Customized search tools allow you to find regional history books about the town where you grew up, the cities where your friends and family live, the town where your parents met, or even that retirement spot you've been dreaming about.